INVENTORUM NATURA

THE WONDERFUL VOYAGE OF PLINY

Una Woodruff

A Dragon's World Ltd. Imprint

Dragon's World Ltd.,
'The Bower,'
High Street, Limpsfield,
Surrey RH8 0DY,
Great Britain.

Distributed by
Phin Ltd.,
Phin House,
Bath Road, Cheltenham,
Gloucestershire,
Great Britain.

Designed by M. Fairbrother and S. Henderson
Translation by D. MacSweeney

ISBN Limpback 0 905895 25 8
ISBN Hardback 0 905895 24 X

Printed in England.

CONTENTS

For
Victoria Jane Euphoria

NOTE
ON THE CIRCUMSTANCES
OF THE DISCOVERY
AND PUBLICATION
OF A FIRST-CENTURY
MANUSCRIPT,
IDENTIFIED AS THE

INVENTORUM NATURA

THE JOURNAL OF
A SCIENTIFIC EXPEDITION
CONDUCTED BY
PLINY THE ELDER
IN SEARCH OF MATERIAL
FOR HIS
'NATURAL HISTORY'

INTRODUCTION

The following text has been transcribed from the re-stored fragments of a manuscript, preserved in the muniments room of an unrenowned though ancient Somerset family, whose manor, remotely situated on a dry hillock in the marshes near the town of Glastonbury, was long the goal of many a fruitless pilgrimage by anti-quarian scholars. The attraction that persuaded genera-tions of eager pedants to leave comfortable rooms and follow will-'o-the-wisps through the Somerset swamps was the rumour that concealed in the old manor house, was a hoard of amazing documentary treasures, includ-ing the works of certain ancient authors, lost since clas-sical times, and unique Celtic manuscripts of Druidic records, setting out the history of the world, the secrets of the prehistoric alchemical science and the true origins of Christianity.

Rumour went on to say that at the time of the sup-pression of Glastonbury Abbey and the hanging of its Abbott for concealing treasures in 1539, the secret, 'locked library' of the Abbey, containing manuscripts kept hidden even from William of Malmesbury during his inspection in the year 1125, was entrusted by the last of the Glastonbury monks, Austin Ringwode, to the safe-keeping of this family. Certain conditions were imposed, together with a blessing and a precautionary curse, and it was said that every subsequent heir, on achieving his majority, was solemnly instructed as to the content and meaning of the documents in the family charge and sworn to deny possession or any knowledge of them until such time as certain portents should an-nounce the moment for revealing them to the public. Up to the present time, no suppliant scholar, however charming or persuasive, has ever stepped over the threshold of the old manor (the family are given wholly

to bucolic pursuits and company), still less glimpsed its legendary treasures. In consequence of repeated disap-pointments, scholars by the end of the nineteenth cen-tury were agreed in abandoning the quest and in adopting a sceptical attitude to the alleged existence of any such hoard. The rumour lost its force and fell into oblivion, and the family has since been left to enjoy undisturbed its rustic seclusion.

The reason for giving these brief, vague indications of the source of our manuscript is to inform those few scholars who will recognize the house in question, still protecting the family from the persecutions of curiosity. Undisclosed circumstances – it may be that the time for revelations is at hand, or it may be that the family now much impoverished, finds difficulty in maintaining the manor house and its contents in proper order – have per-suaded the present heir to reveal privately certain facts of his hereditary trusteeship and to authorise the publi-cation of one item from the secret library. His condition was that it should be restored by the most expert hands from the mouldy state to which the centuries passed in the damp vaults of the old manor had reduced it, and, after being copied, returned secretly to him.

At the beginning of a Carbon-dating test to deter-mine age, two fragments of the precious manuscript were inadvertently destroyed, their contents lost forever. The owner, understandably, now refuses to allow the manuscript into any hands other than his own or those of the most dedicated scholar. He is more than suspicious of technology and swears "never to have modern flim-flam" near him again. Even the camera is banned. Thus it is not possible to reproduce here the actual text pages or the faded anatomical drawings, once finely coloured, with which the work is ornamented.

These, together with the details given in the text, have provided the antiquarian artist, Una Woodruff, with the material for her scientific reconstructions, included in this edition, of the biological specimens as seen and recorded by the writer of the manuscript. This same artist was also responsible for discovering the authorship of the work. On the basis of the unrestored text, scholars had at first been inclined to identify the manuscript as a Roman translation of the legendary, long-lost *Arimaspea*, a poem composed by the 7th-century B.C. Greek shaman, Aristeas, whose feats, recorded by Herodotus and many other classical writers, included his making simultaneous appearances at places many miles apart, turning up in Italy two hundred and forty years after his recorded disappearance in Greece, and flying by the force of teleportation to a paradise land somewhere deep in Russia, where he encountered a race of one-eyed men and a species of griffin, unknown to Europeans of his time and now apparently extinct. Both these types are described in the manuscript, thus explaining the scholars' original false attribution.

In the Spring of 1978, Una Woodruff's paper in the *Proceedings of the Institute of Fringe Biology* established beyond all doubt the authorship of the manuscript and identified it as a previously unknown work by Pliny the Elder (23–79 A.D.), being the journal of his three-year expedition to distant lands, begun in about 53 A.D., with the object of making first-hand observations of the creatures he was later to describe in his monumental *Natural History* (77 A.D.). This was subsequently confirmed by the deciphering, with the aid of new computerized image-augmentation techniques, of a badly stained fragment of the original manuscript containing the dedication.

Pliny was one of the most fanatical scholars who ever lived, working for days and nights on end in the library of his palace, grudging the few hours he had to spend in sleep and engaging a lector to read aloud from a book while he ate, bathed and rested. At the same time he led an active life of high public duties as lawyer and administrator, occupying the post of Procurator in Spain and becoming the intimate counsellor of his fellow scholar, the Emperor Vespasian. His scientific curiosity led to his death at the age of 56, when he was overcome by poisonous fumes while making an excessively close investigation of an eruption of Vesuvius.

Scholars have long disputed as to whether Pliny had ever journeyed, like Darwin in the *Beagle*, in search of material for his *Natural History*. This new discovery, that he not only made such a voyage but also compiled detailed on-the-spot notes of the animals and plants which he and his colleagues personally witnessed, settles once and for all that particular controversy. It raises, however, another question of far greater interest. Since the biological specimens illustrated here were evidently in existence at the time of Pliny's voyage, how is it that they have all since disappeared? The latest theory of fringe biology suggests that the phenomena of natural history are subject to fluctuation in different ages and cultures. In our own time there are many creatures that seem to be hovering on the borderline between a real and a phenomenal existence. These include the archaic reptiles seen in Loch Ness and in lakes and rivers elsewhere, the hairy, man-like giants in the mountains of Asia and North America, and the giant birds, resembling the thunderbirds of traditional Indian lore, that have been sighted in recent years over many of the United States. Several of the creatures have been photographed but none of them has yet been caught. They cannot yet, therefore, be classified among the 'real' animals of current natural history, but their persistent occurence over many centuries, recorded in folklore traditions all over the world, proves their occasional or intermittent existence and hints at their ability to make spontaneous reappearances, like the supposedly long extinct Coelacanths, at different periods of history.

Several of the human races, animals and plants, described here in Pliny's *Journal* and figured in Una Woodruff's reconstructions, have never since been recorded and must be considered, temporarily at least, to be extinct. Others have been sighted at various times up to the present day and may be due for future revival. This question is most properly left for the consideration of experts in fringe biology. It is hoped that their studies will be considerably advanced by the publication of this newly revealed manuscript, and that scholars, naturalists and all lovers of antique curiosities, will find pleasure and instruction in the unique glimpse of natural history in the ancient world here provided.

John Michell 1979

PRAEFATIO

Plinius Secundus Vespasiano★ Suo S.

Hoc opus, Inventorum Natura inscriptum, natum apud me proximis studiis dedicare constitui tibi, iucundissime imperator.

quo libello, dum tres annos ad mundum explorandum navigabam scripto, ex veritate narrantur illi mirabiles casus naturae qui in partibus longuinquis mundi inveniuntur, multaeque species atque genera adhuc numquam perscripta illic continentur.

equidem ita spero, aliquantum tibi prodesse harum paginarum studium, quia bene scio quantum omnia quae ad artem scientiamque pertinent tua intersit.

Preface

Plinius Secundus to his dear Vespasian,★ greeting.

Most Gracious Highness, I have resolved to dedicate to you this work, entitled Inventorum Natura, the product of my most recent studies.

This volume, written during my three year voyage of exploration, is a true account of those curiosities of nature to be found in the most distant parts of the world, and includes many species hitherto unrecorded.

It is my hope that you will find some usefulness in the study of these pages, knowing, as I do, the interest you have in all aspects of the arts and sciences.

★**Note:** The emperor Titus.

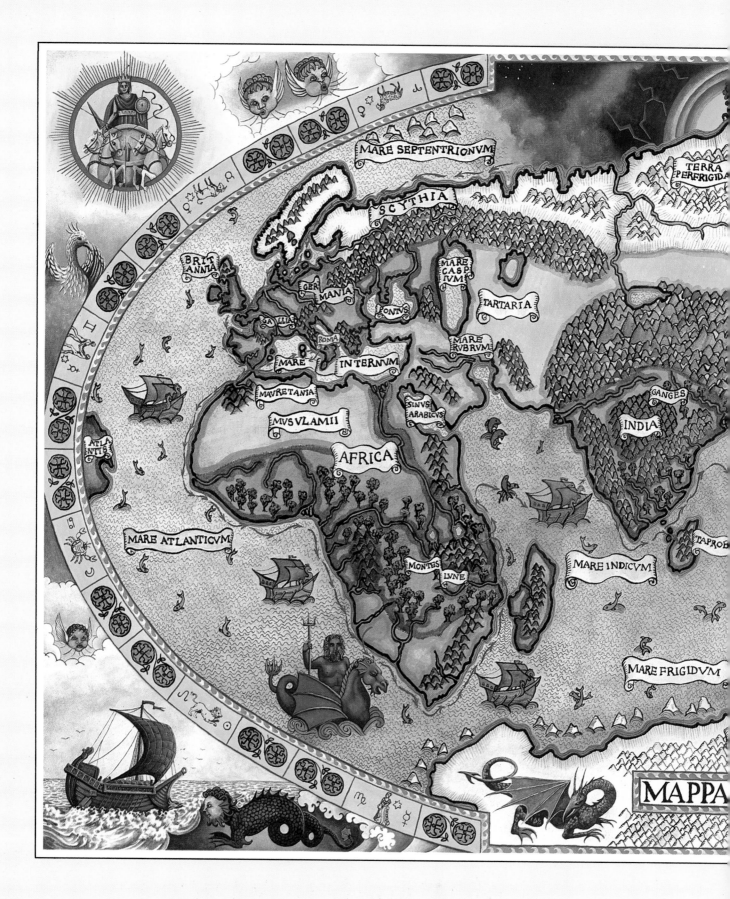

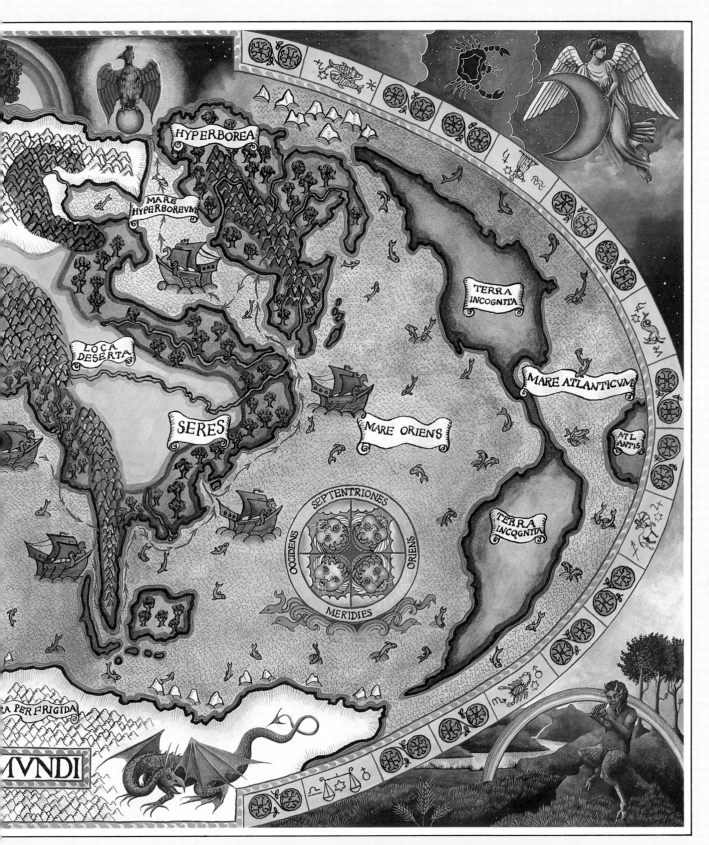

MAP OF THE WORLD

NAVEM SOLVIMUS

Ego, Gaius Plinius Secundus, comitesque duo mei, Carolus Andrivus, vir doctus atque Una Silvana pictor, iter nostrum duodecimo anno quam Claudius imperator factus est incepimus. nautae navis nostrae, Aelgaibi nomine, duodecim servi fideles erant, qui propter fidum officium manumissi sunt.

Kalendis Maiis igitur e portu Miseno vela dedimus, atque primum ad Melitam insulam pervenimus.

The Ship Sets Sail

I, Gaius Plinius Secundus, and my two companions, the scholar Carolus Andrivus, and the artist Una Silvana, began our journey in the twelfth year of the reign of Claudius. Our ship, the *Aelgaibus,* was crewed by twelve trusted slaves who have become free men in respect of their loyal service.

We set sail on the first day of May, from the port of Misenum, and came first to the island of Melita.

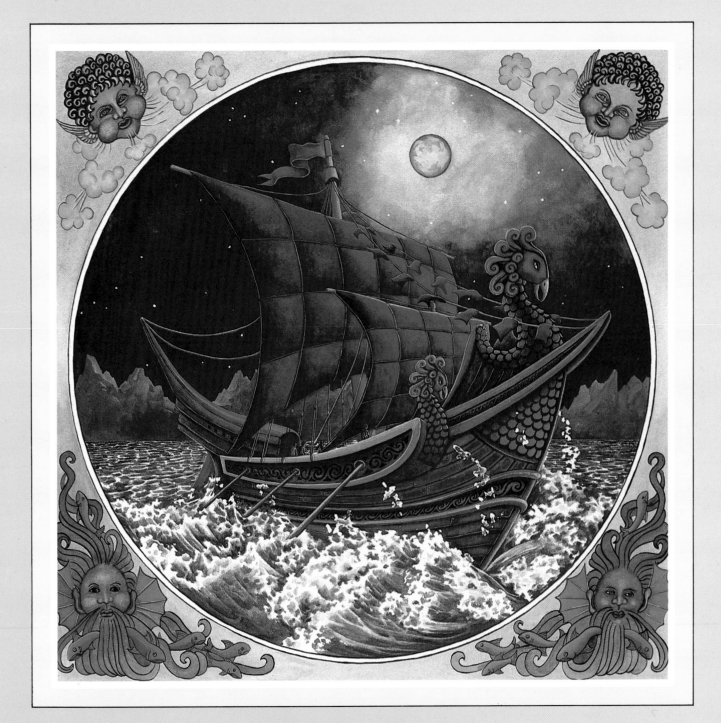

The Ship Sets Sail

Pl. I

DE PYRALLIBUS

Itinere tertio die repetito, nocte quadam magnopere procellis tonitribusque conturbati sumus, propter eruptionem ignium e montis in parva insula vertice, quam appropinquavimus, ut eam contemplari possemus.

et medio igni et cinere volabant pinnata quaedam; pyralles appellantur, a quibusdam pyrotoca, quae et in Creta, aerariis fornacibus inveniuntur. draconibus aliquantum sunt similia, pinnas tamen insectorum habent.

Pyrallis eodem modo fetus progenerat ut alia insecta. in flammis alimenta invenit, quamdiu in igni solum vivit.

Pyrallis

We continued on our journey after two days. One night, we were greatly disturbed by storms and thunderous noises, caused by the eruptions on a small volcanic island, which we approached in order to make observations.

Flying amidst the flames and cinders were small winged creatures. These are the Pyrallis or Pyrotocon, which can also be found in the copper foundries of Crete. They bear some resemblance to dragons, but have the wings of insects.

The Pyrallis reproduces in the same way as most insects. It draws nourishment from the flames, and is only able to survive in the element of fire.

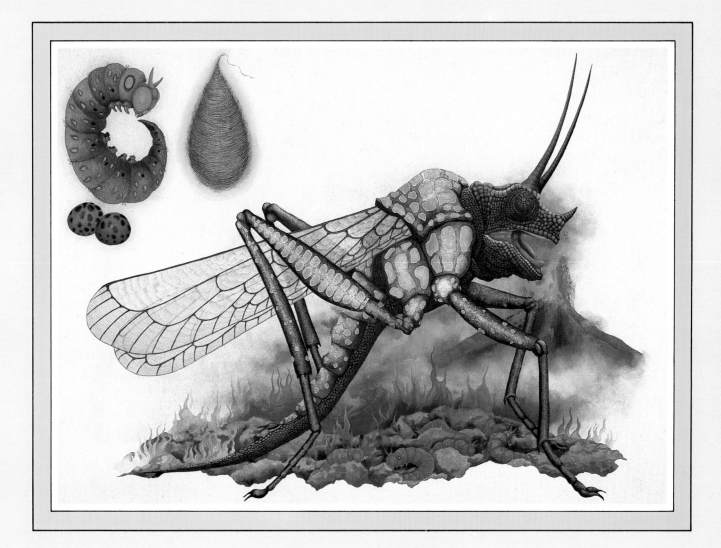

The Pyrallis

Pl. III

DE POMIS AUREIS

In litore Africae inter septentriones et occasum solis
spectante colonia est Lixus. hic bracchium maris in
terram porrigitur insulam complexum, quo tempore
praeterito situs erat nemoris illius celebris aurea
poma ferentis.

unum solum arborem huius nemoris
invenire potuimus. quamquam fructus ferebat,
ramis etiamnunc flores remanebant rari. flosculi
splendidissime refulgent, sicut lamina aurea, fructus
ponderosi globi aurei sunt. in medio structuram
offert caro similem aeris crystallis.

ex ramis arborum proximorum bombones
magnorum insectorum iratorum, crabronibus
similium, dependent. corpora dura metallo similia
habent, pinnasque aureas refulgentes. per totam diem
sucos e fructibus maturis carpunt; solis occasu
denique sono graves fiunt, itaque propius licet eos
intueri.

in nidis cellas habent, sicut apes, et mellem
quandam faciunt ad fetus nutriendum. hic liquor
autem tam calidus est ut non tangi possit, et aurum
liquefactum esse videtur.

Golden Fruit

On the north-west coast of Africa is the colony of Lixus. Here, an arm of the sea
stretches inland embracing within it an island, which, in bygone times, was the site of
the famous grove that bore the golden fruit.

We are able to discover but one tree remaining of this grove. Although the tree was
in fruit, a few flowers remained on the boughs. The petals shine brightly and are like
gold foil. The fruits are heavy golden orbs. Inside, the flesh has a structure resembling
the crystals of metallic ore.

From the branches of adjacent trees hang the hives of large angry insects, like
hornets. They have hard metallic bodies and wings of flashing gold. Throughout the
day they gather juices from the bursting fruit. At sunset they become drowsy,
allowing for close examination.

Inside their nests they have cells, like bees, and manufacture a honey-like substance
for the nourishment of their young. This liquid, however, is too hot to touch and
appears to be molten gold.

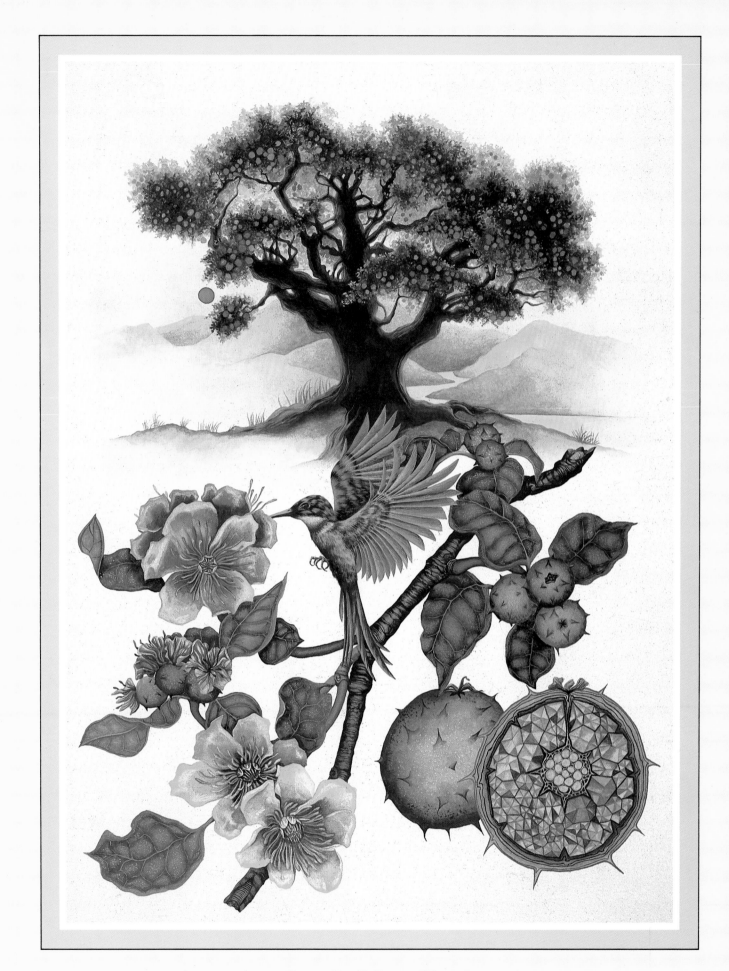

The Golden Fruit

Pl. IV

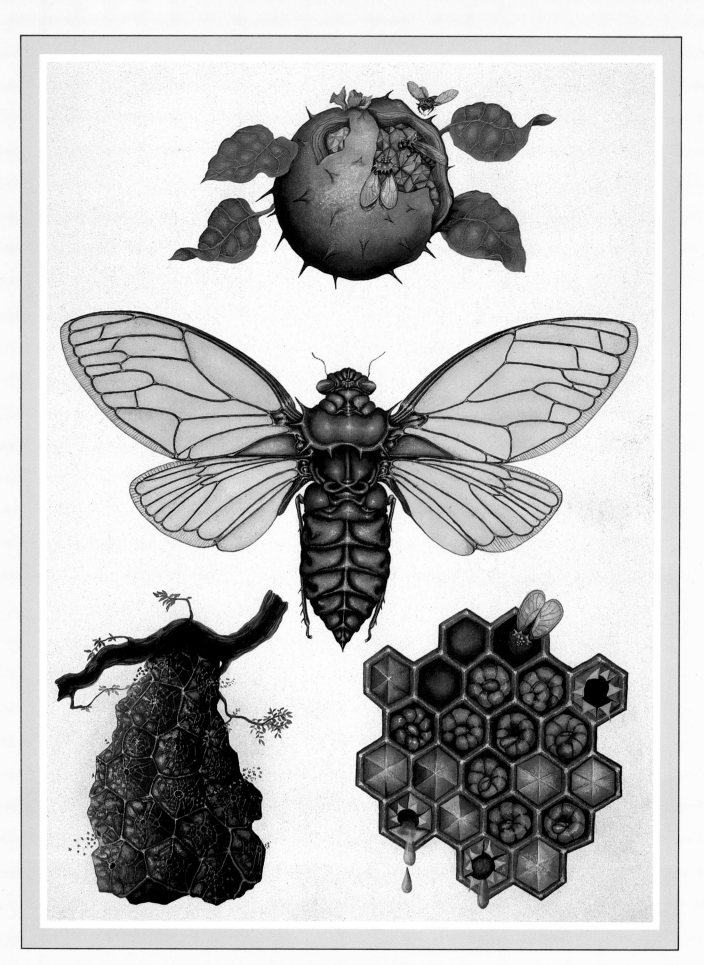

The Gold Bee

Pl. V

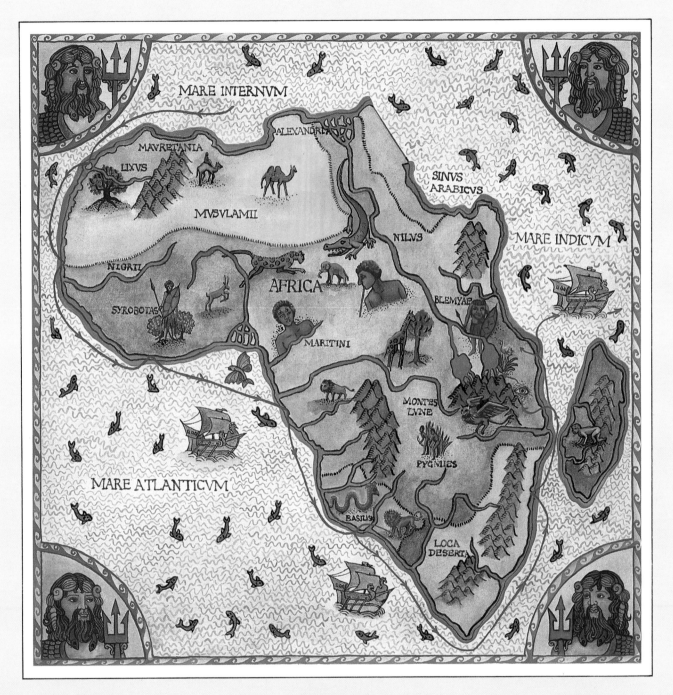

Map Of
AFRICA

DE PAPILIOPISCIBUS

Vulgo creditur simulacra omnium naturalium quae in terra inveniantur et in mari inesse. quod enimvero multis exemplis confirmatur, maris equo videlicet, cucumi, uva, calamo, ceterisque plurimis.

apud litus Africae occidentalis piscium genus invenimus formam papilionis habentem, quorum complures claro fulgentes colore iuxta undas volitantes conspeximus. fetus erucis similes in aequore fluitant, et aqua ipsa pasci videntur. quod genus papiliopisces appelavimus.

Butterfly-Fish

It is a common opinion that the sea contains the likeness of everything in nature that is to be found on land. There are many examples to support this theory; the sea-horse, the cucumber fish, the sea-grape, the sea-pen, and numerous others.

Off the coast of West Africa we discovered a variety of fish that has the appearance of a butterfly. We observed a number of these brightly coloured creatures flying close to the waves. Their young are like caterpillars, float near to the surface of the sea, and seem to be nourished merely by the water itself. We have named this species the Butterfly-Fish.

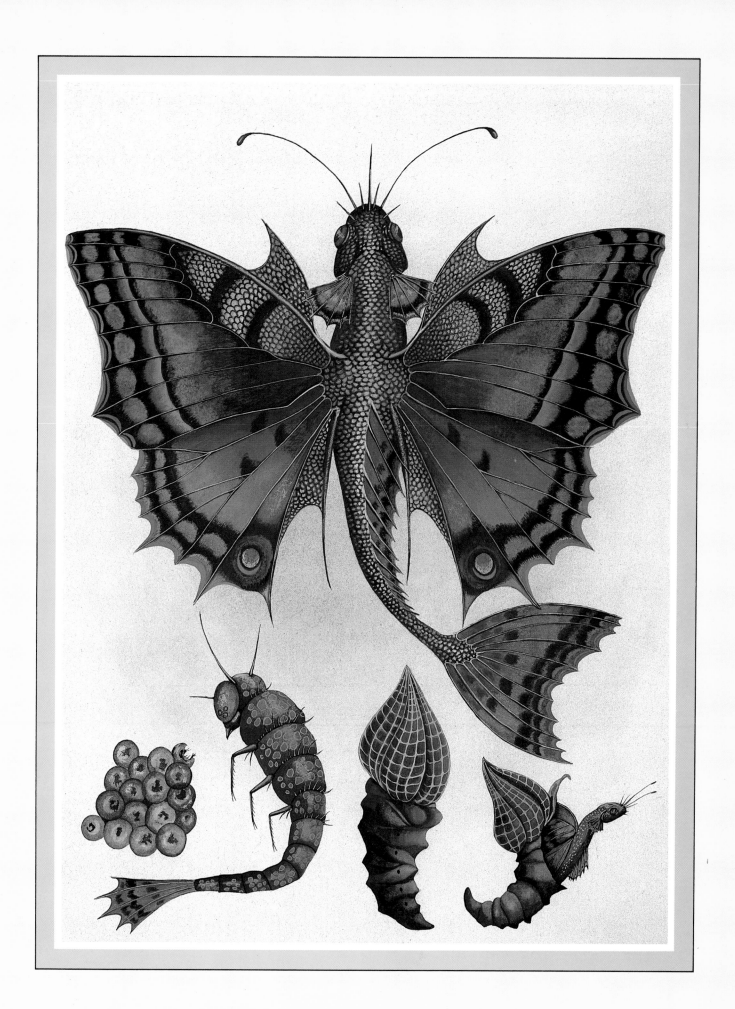

Butterfly Fish

Pl. VI

DE BASILISCIS

In locis desertis Africae australis habitant illi
serpentes formidulosissimi, basiliscos lego.

 ubicumque commorantur, regionem in locum
desertum convertunt. vis oculorum obtutus tam
exitialis ut rumpere saxa, herbas exurere aspectu solo
possint. aves et medio volatu concidant, et [. . .] ★
aqua ipsa unde sitem sedant iam inde venenata
manet. quorum primum dicitur de Gorgonis
sanguine genitum; fetus tamen ova pariendo
progenerant, quae bufonibus ortu Caniculae
incubantur.

 omnium animalium mustellae solae his talibus
monstris nil mali concipiunt, sed simul conspectos
statim oppugnare solent. creditur etiam basiliscos
cantum gallorum timere.

Basilisks

The deserts of Southern Africa are inhabited by the most terrifying of serpents, the
Basilisks.

Basilisks turn the countryside into desert wherever they live. The venom of their
stare is so powerful that they can split rocks and scorch grass merely with a glance.
Birds fall dead in flight, and [....]★ the water where they quench their thirst remains
poisoned. It is said that the first of these creatures was born from the blood of the
Gorgon. However, they continue their generation by laying eggs which are hatched
by toads at the time of the Dog Star.

Of all animals, only weasels remain unaffected by these monsters, and will attack
them on sight. In addition, it is believed that Basilisks are fearful of the sound of
roosters crowing.

★Note: Here the manuscript is badly damaged and only a few words are decipherable. The phrase 'killing both at once through the infection in the spear...' (utroque occiso per hastam subeunte vi) is, however, distinguishable. In his 'Natural History,' (Book VIII, chapter XXXIII, line 78) Pliny says: "It is believed that one (Basilisk) was killed with a spear by a man on horseback and the infection rising through the spear killed not only the rider but also the horse." (creditur quondam ex eque occisum hasta et per eam subeunte vi non equitem modo sed equum quoque absumptum.) Pliny is probably relating the same story at this point.

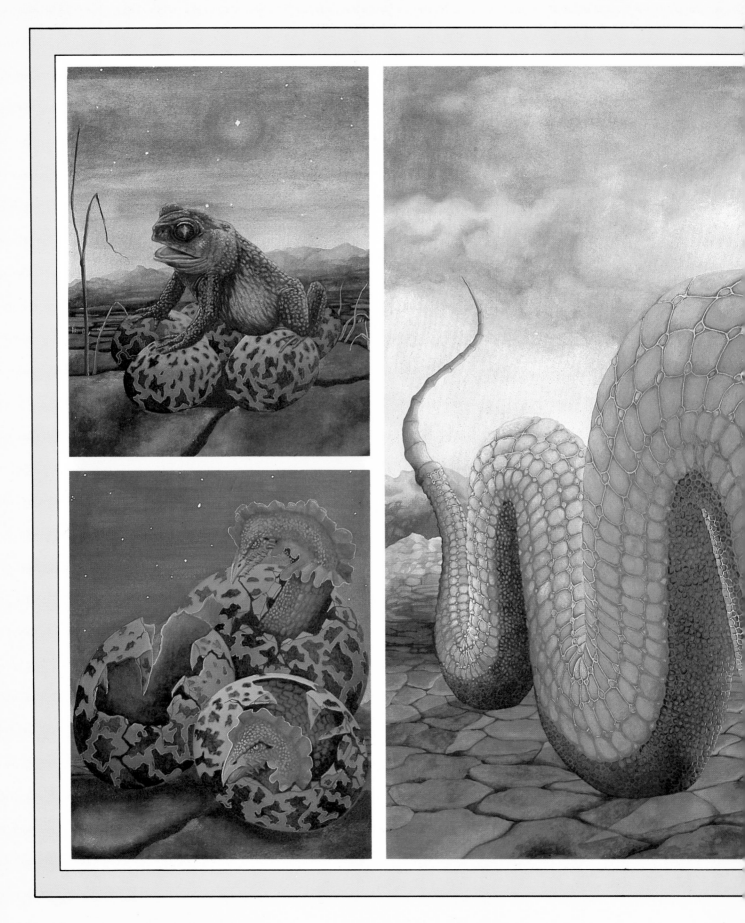

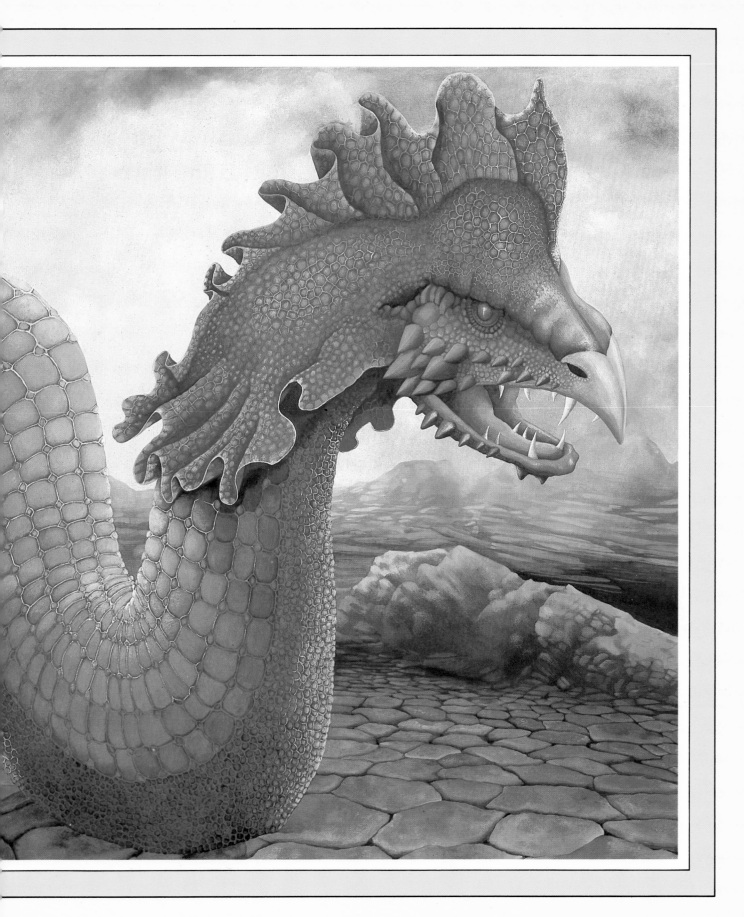

Basilisks

Pl. VII

DE MANTICHORA

Ad litus reversi per silvas invias transiimus quas incolant Mantichorae.

quae corpus leonis sanguineo colore, faciem hominis habent, in faucibus tamen treilicem dentium ordinem pectinatim coeuntium [. . . .] *caudas scorpionis modo spicula venero exitiali infigentes.

Mantichorae summum periculum intendunt, propter magnam velocitatem, praeterea humani corporis vel praecipue adpetentes.

Mantichorae

On our return to the coast, we passed through the jungle wherein live the Mantichorae.

These have the appearance of gigantic red lions. Their faces are like those of men, but, within their jaws, they have three rows of teeth which interlock like the teeth of combs [....]* tails are like those of scorpions, tipped with deadly poisonous stings.

The Mantichorae are most perilous creatures, being very swift and, moreover, desirous above all of human prey.

***Note:** The text is indecipherable at this point, but the word 'vocis' (voice) can be distinguished. In his 'Natural History', (Book VIII, chapter XXX, line 75) Pliny describes this as being: "like the sound of a pan-pipe blended with a trumpet" (vocis ut si misceatur fistulae et tubae concentus).

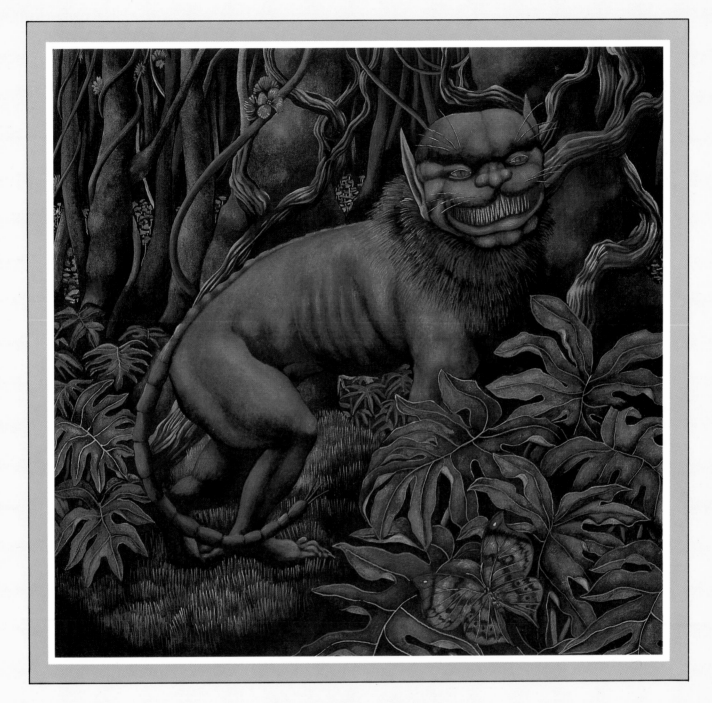

The Mantichora

Pl. VIII

DE MERMECOLIONE

Itaque praeter promuntorium austrinum Africae navigavimus, et ad montes lunae equivitavimus. [. . . .]★

dum per desertam regionem raris silvis et graminibus transimus, mermecolion invenimus, mirandam speciem leonis et formicae mixtura multiformem, quae ex ovis formicae semine leonis in terram cadenti immixtis generatur.

quamquam saevum aspectum habet, mermecolion innocuus est, quia propter naturam multiformem nihil vesci invenire potest, quamobrem vitam brevissimam degit.

Mermecolions
We sailed around the southern tip of Africa and made our way on horseback to the Mountains of the Moon. [....]*
Whilst passing through a sparse area of woods and grasslands we found the Mermecolion, a marvelous hybrid of the lion and the ant. Its generation is caused by the seed of the lion falling on the ground and impregnating the eggs of ants.

Although it has a ferocious appearance, the Mermecolion is harmless as it is very short lived, being unable to find suitable nourishment because of its hybrid nature.

*Note: There is a passage of text here which is too badly obscured to be deciphered. It seems to relate examples of the hybridization of lions, a phenomenon which Pliny describes in his 'Natural History,' (Book VIII, chapter XVIII, line 42). According to Aristotle in his 'Historia Animalium,' lions mate indiscriminately with unlike species and produce monstrous hybrids.

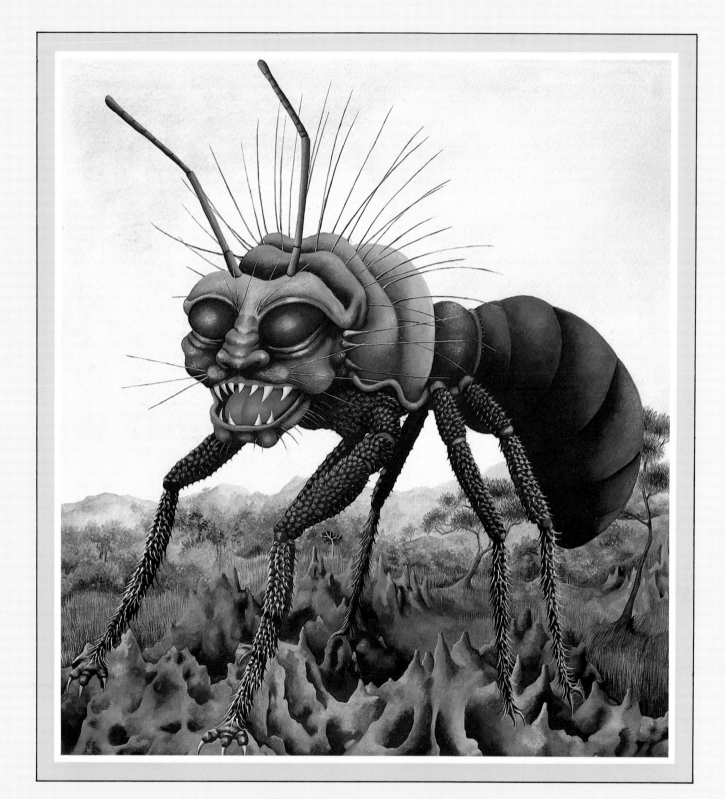

The Mermecolion

Pl. IX

DE GRYPIS

Montes lunae crystallis gemmisque refulgent, sed feris grypis custodiuntur. qui monstri dimidiam partem aquilae, dimidiam et leonis habent, atque tanti sunt ut homines unguibus rapere possint.

huius regionis incolae Arimaspi vocantur, uno oculo in fronte media insignes, quibus adsidue bellum est cum grypis, ut thesaurum eorum possidant. monstrorum ungues in poculos, costasque in arcus fingunt.

Griffins

The Mountains of the Moon are bright with crystals and precious minerals, but are guarded by savage Griffins. These are monstrous beings, half eagle, half lion, and large enough to carry away men in their claws.

The local tribesmen are a one-eyed race called Arimaspians. They do battle with the Griffins in the hope of possessing their treasure. They make the claws of the monsters into cups, and their rib bones into bows.

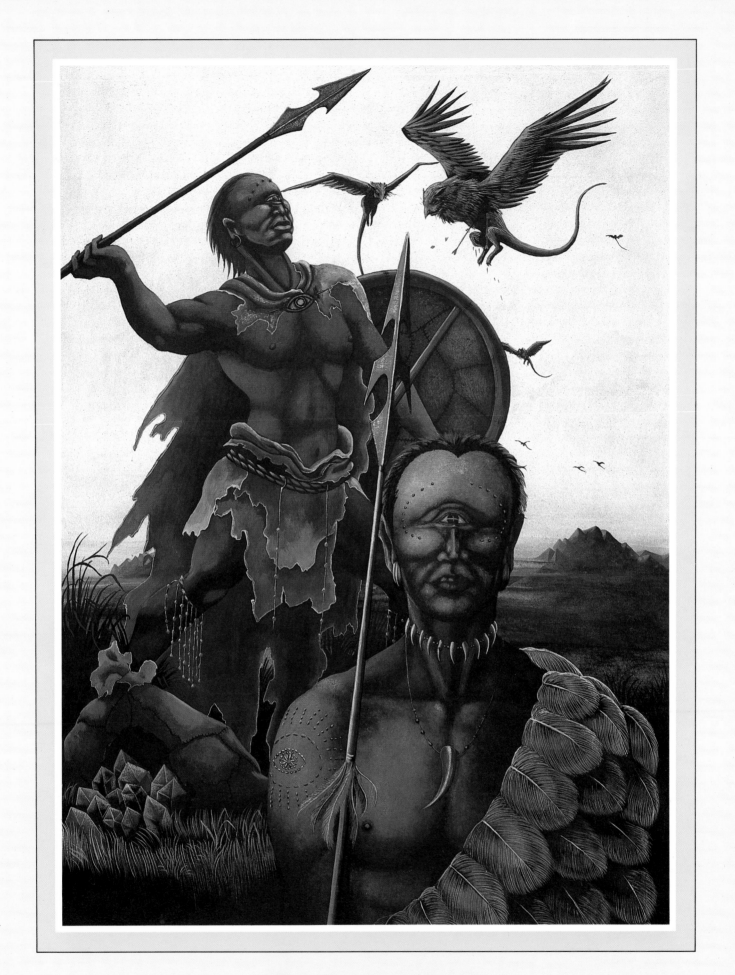

The Arimaspians

Pl. X

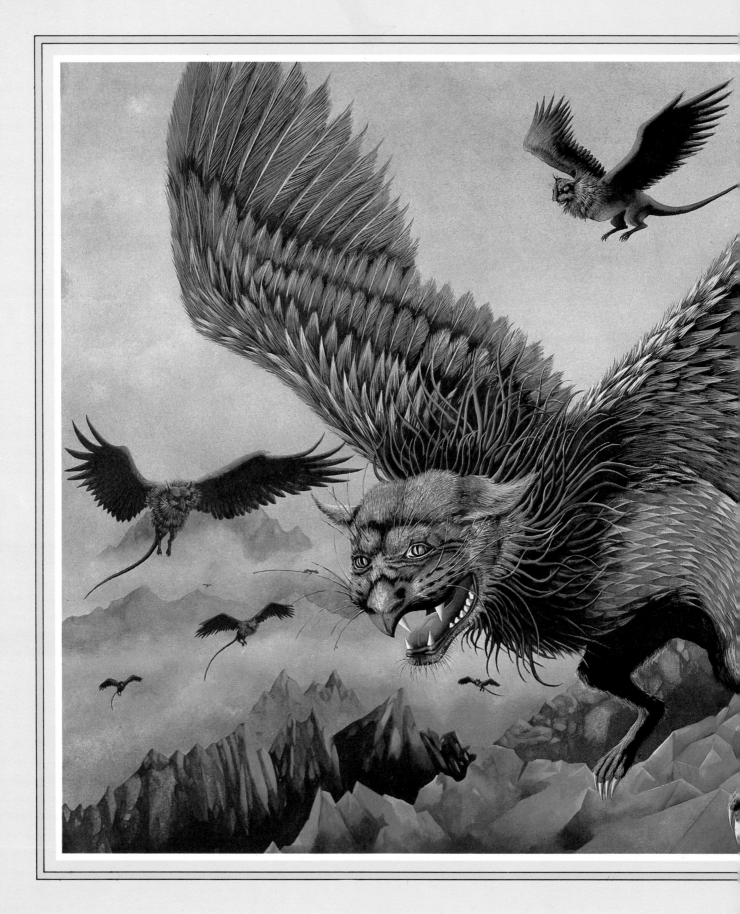

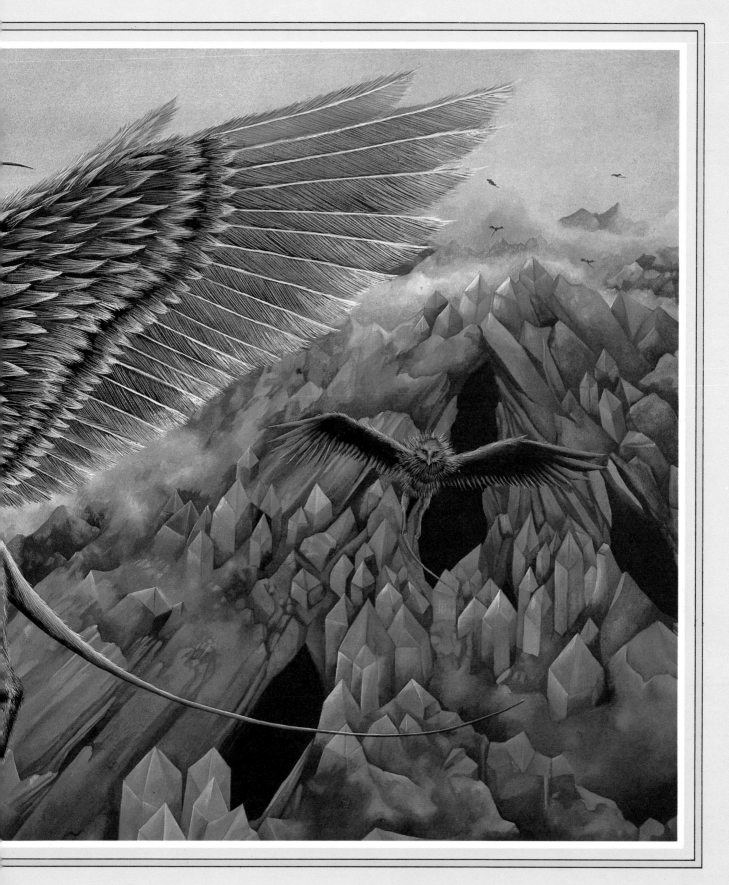

Griffins

Pl. XI

DE AVIBUS AQUATICIS

Inde ad ripas pervenimus geminorum lacuum de quibus oritur magnum flumen Nilus.

crepidinibus lacuum aves herbaeque omnis generis congregantur, praesertim milia avium rosearum piscibus★ vescentium, cruribus longis, quae de harundinibus aquae in margine crescentibus generantur.

Water Birds

We reached the shores of the twin lakes which are the source of the great river Nile.

The margins of the lakes are crowded with birds and plants of every description. In particular, there are thousands of pink fish-eating birds★ with long legs, which are generated from the reeds growing at the water's edge.

★**Note:** Here the manuscript is badly damaged. The text has been inferentially reconstructed. This could read 'piscatoribus' (fishermen), meaning that the birds eat the fishermen.

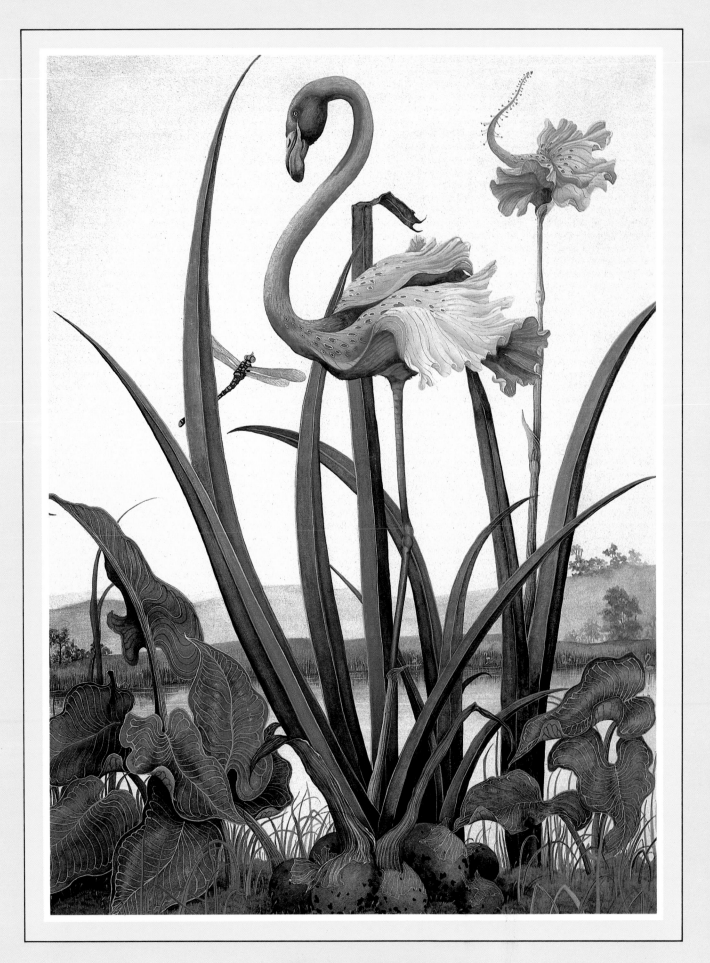

Water Birds

Pl. XII

DE BLEMMYIS

Multae mirae gentes *Africam incolunt, quorum sunt
et gigantes, qui Syrobotae vocantur, et parvi
homines, nomine Pygmaei, ternas spithamas
longitudine non excedentes, Machylesque androgyni
utriusque naturae, Maritimi quaternos oculos
habentes, Limantopodes sicut animalia bracchiis
cruribusque repentes, atque alia gens hominum ore
carentium, quibus necesse est per culmos alimenta
in sese haurire.

occurrimus et genti Blemmyis, quibus capita
absunt, ore et oculis pectore adfixis; quod tamen non
videtur magnum eis esse incommodum, nisi quod
totum corpus vertere debent ut circumvideant, cum
colla eis non prosint. sicut alii feroces Africae gentes,
consuetudinem habent humanibus corporibus vesci.

Blemmyae

Numerous strange races of men* live in Africa. There are races of giants called Syrbotas,
small men called Pygmies whose height does not exceed three spans, the Machlyes who
are of dual sex, the Maritimi who have four eyes, the Limantopodes who walk on all
fours, and a race who do not have mouths and have to feed through straws.

We encountered a tribe, the Blemmyae, who have no heads, but faces on their chests.
This does not seem to inconvenience them greatly, except that they have to turn their
whole bodies in order to see about them, not having the advantage of possessing necks.
Like other savage peoples in Africa, they are in the habit of eating human flesh.

*Note: Pliny describes more of these curious races
in the 'Natural History,' (Book VII, chapter II).

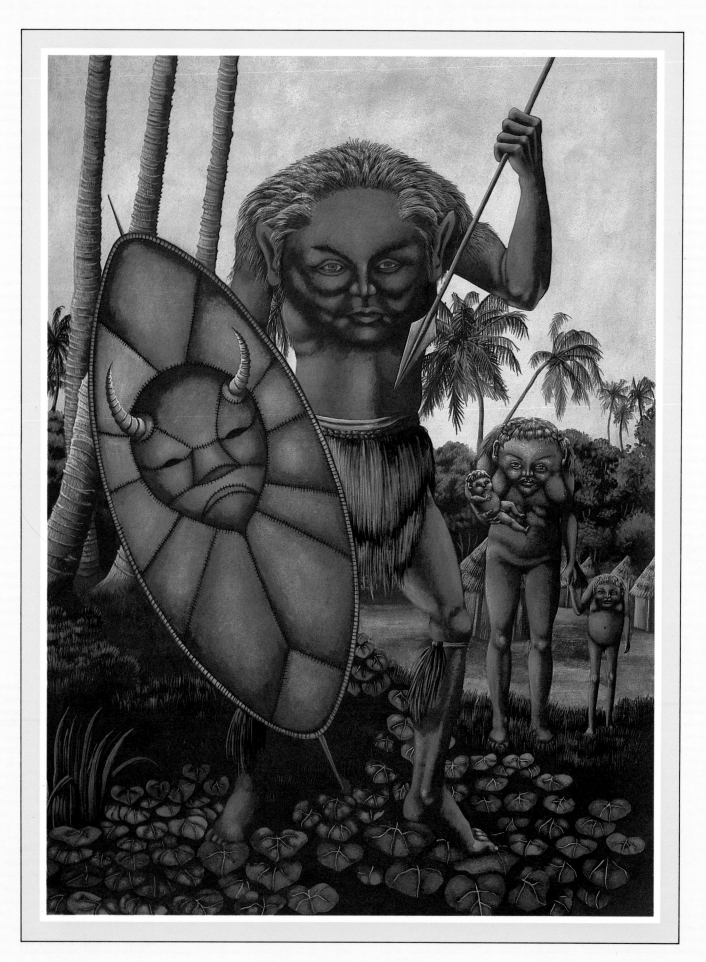

The Blemmyae

Pl. XIII

DE MARIS DRACONIBUS HYDRIS MARINIS

Inde in navem regressi, ad litus Arabiae navigavimus. gregem beluarum vel serpentium marinorum praeteriimus, quos primo aspectu parvas insulas esse putavimus.

praefectus quidam Alexandri Magni classis, Onesicritus, prodidit tales hydros marinos naves classis adnatantes nautas terruisse.

Sea Dragons

We returned to our ship and sailed towards the coast of Arabia. We passed close to a group of sea monsters or dragons, which we took at first to be small islands in the sea.

A commander of Alexander the Great's navy, Onesicritus, reported such sea serpents, which swam alongside ships of the fleet and caused great terror to the men on board.

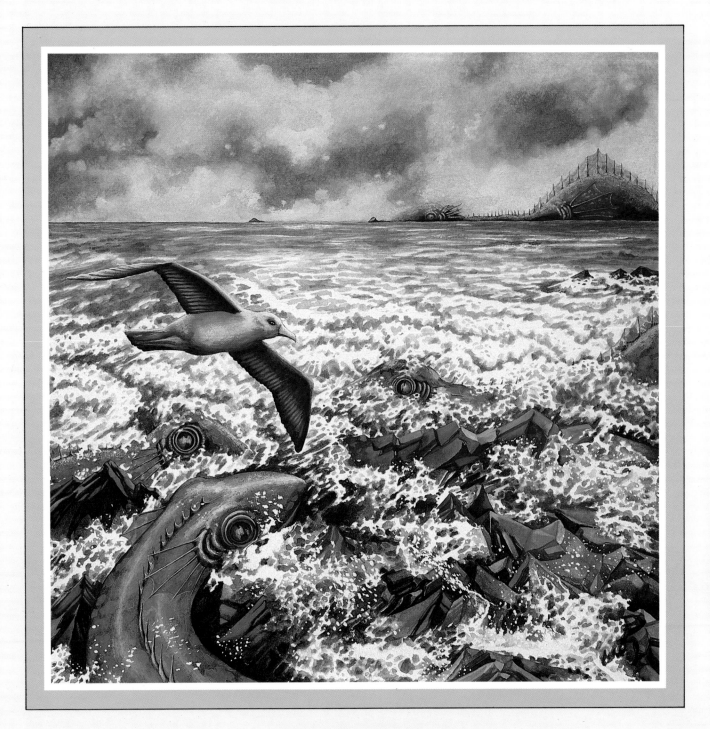

Sea Dragons

Pl. XIV

Dum trans mare Indicum navigabamus, multis in
mari iterum inveniuntur; arborum, avium et
saepius formae animalium terrenorum et in
mari iterum inveniuntur; arborum, avium et
insectorum simulacra sub aequore vivere videntur.
pisces enim conspeximus araneis similes, qui
texta aranea fingunt ut alios pisces minores capiant.
sunt et pisces equis similes, rarius autem aliqui
cornibus medio fronte eminentibus, sicut
monoceratum qui Indiam accolunt.

Curiosities Of The Sea

On our journey across the Indian Sea, we en-
countered many strange and monstrous life
forms in the water.

Often, the appearance of land creatures is
echoed in the ocean life. The likenesses of trees,
birds and insects are to be seen living beneath
the surface.

We observed spider-like fish which make
webs in order to catch other, smaller, fish. There
are also fish with the likeness of horses and, more
rarely, some with horns projecting from their
foreheads like those of the unicorns which
inhabit India.

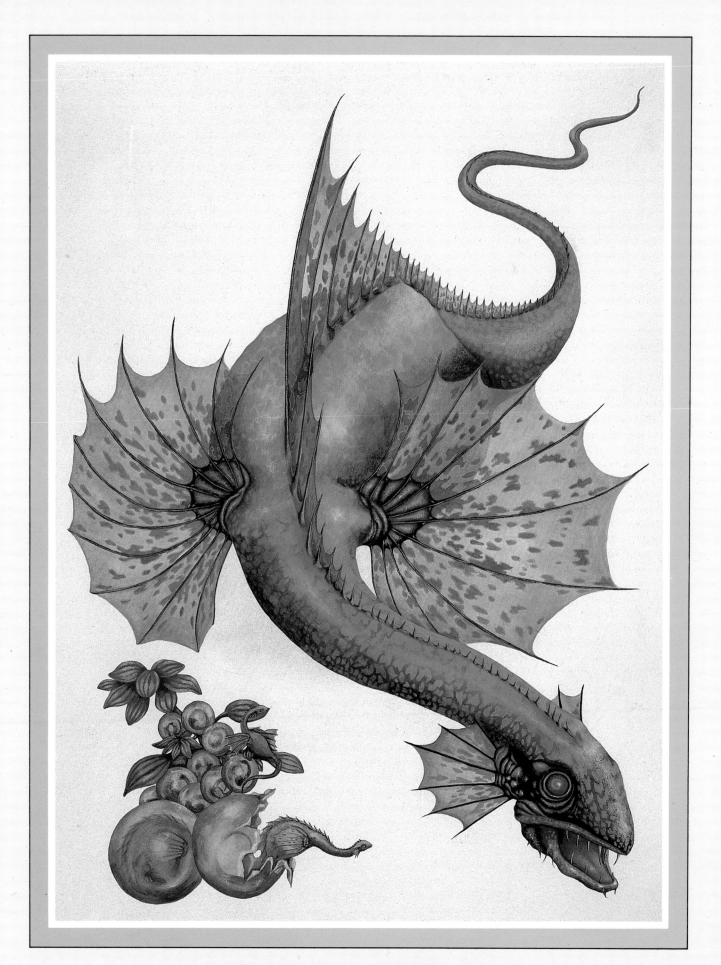

Curiosities Of The Sea

Pl. XV

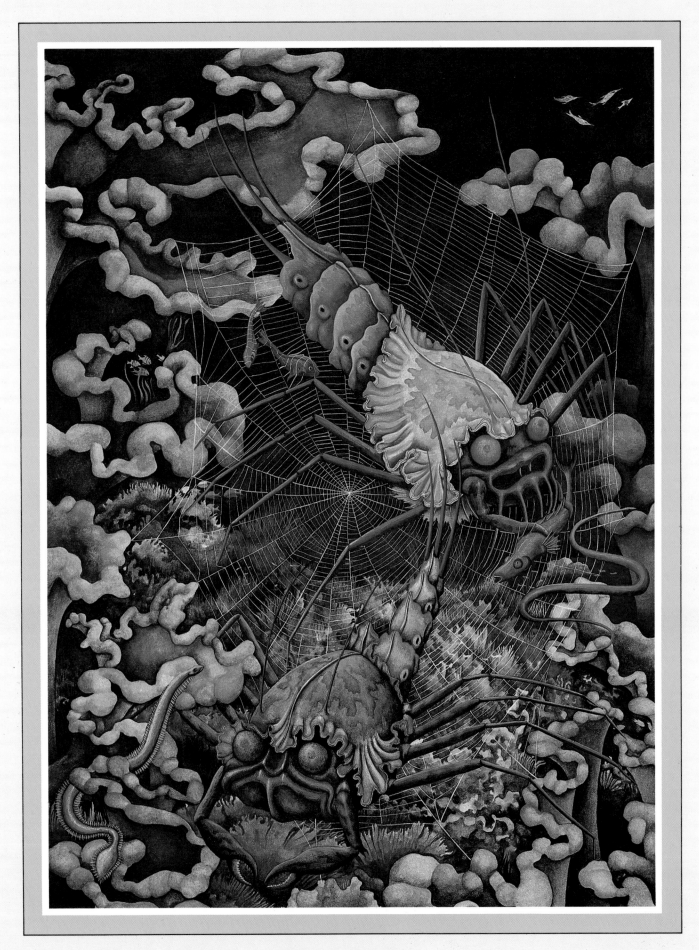

Sea Spiders

Pl. XVI

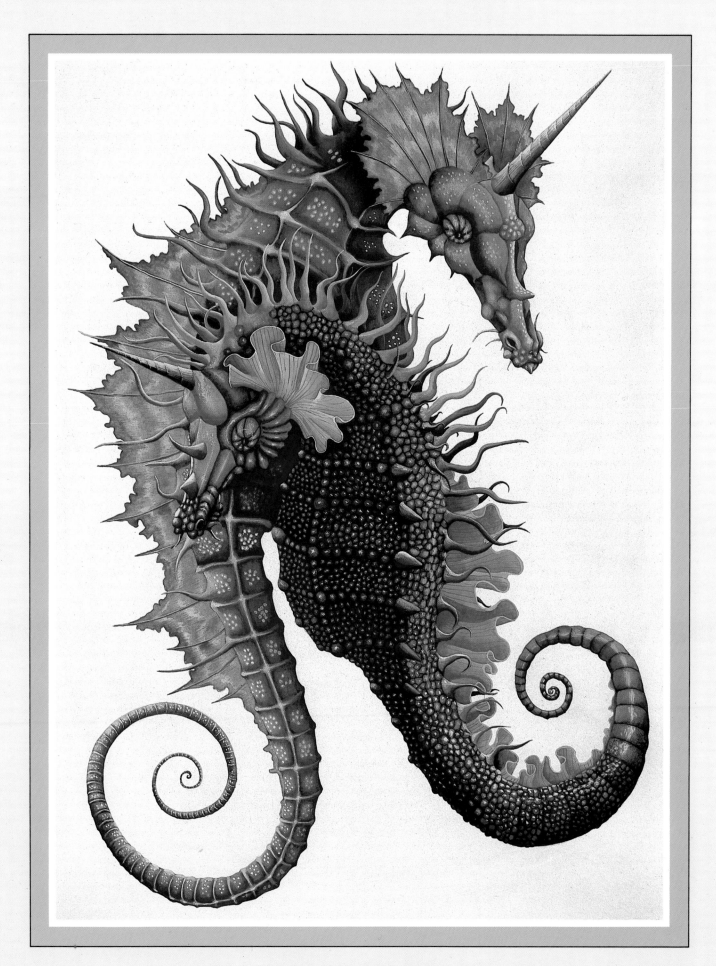

Sea Unicorns

Pl. XVII

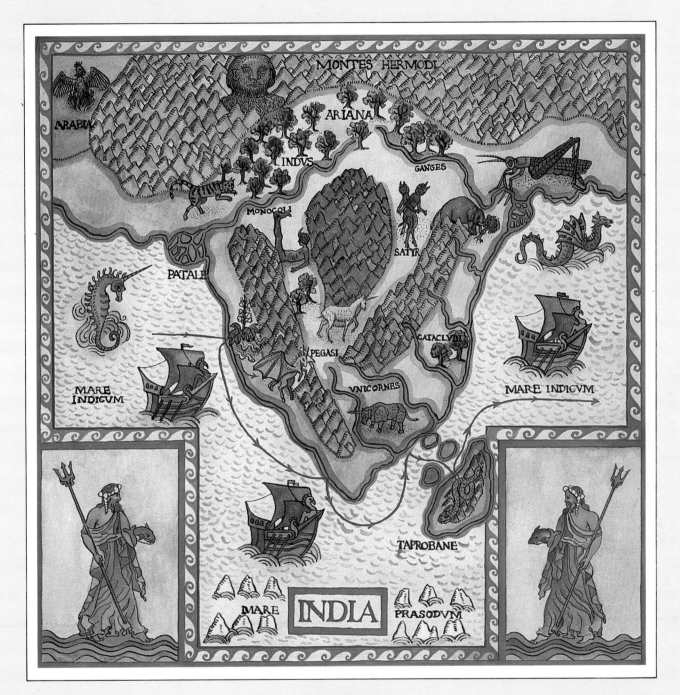

Map Of
INDIA

DE HERBANGUIBUS

Deinde ad litus occidentale Indiae pervenimus, sub faucibus Indi amnis, et sinu tranquillo ex navi egressi, per rus interius processimus fecundum, omni cultu tamen vacatum propter herbas quasdam illic abunde crescentes.

quae flores albos ferunt innumerabilibus minutis serpentibus venenatis refertos. eaedem herbae multis hominibus equisque in Alexandri Magni expeditiones missis mortis causa fuerunt.

Snake Plants

We arrived at the western coast of India, south of the mouth of the Indus, and disembarked in a quiet bay. We made our way inland through fertile countryside which is nevertheless made uninhabitable by certain plants which grow there in abundance.

These bear white flowers which continually generate many thousands of small venomous snakes. The same plants caused the deaths of many men and horses during the expeditions of Alexander the Great.

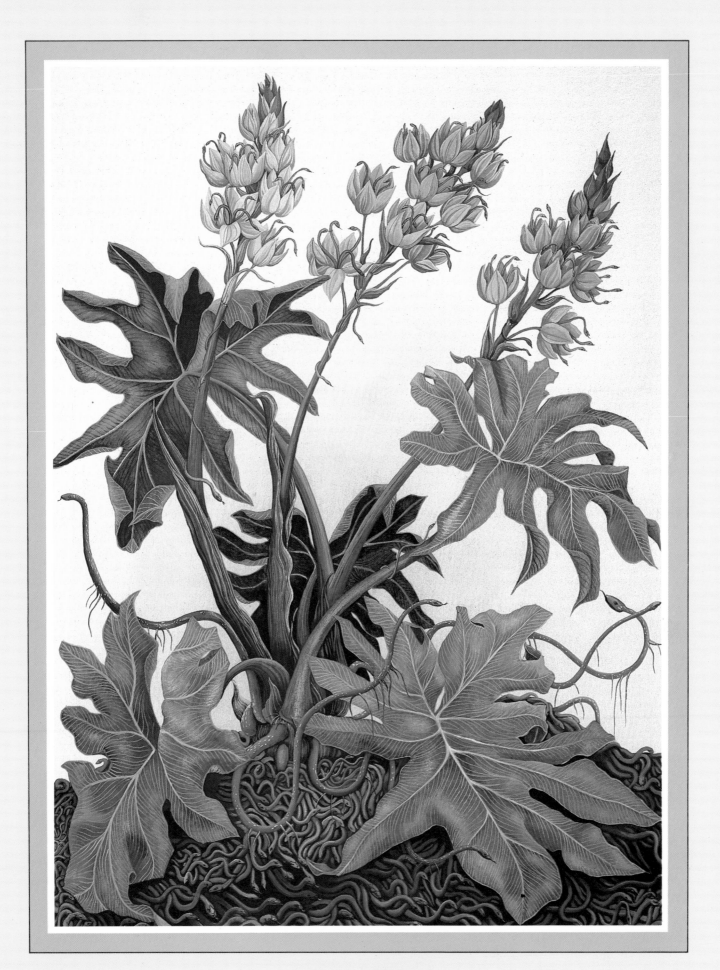

Snake Plant

Pl. XVIII

DE PEGASIS

Inde saxa et cautes montium occidentalium ascendimus ad terram quam mox ingressuri eramus conspiciendam. subito attoniti sumus magno pinnato quodam qui de coelis descendit et in proximos campos insedit.

equo similis erat, sed pinnis vespertilionis, cornibus cervi. haec animalia incolae huius regionis pegasos vocant. haud multum de moribis eorum notum est, quia invia montium summa accolunt, et raro videntur.

Pegasi

We ascended the rocky crags of the Western Mountains to survey the land we were entering. We were surprised by a great creature which descended from the skies and alighted upon a plateau nearby.

The creature had the appearance of a horse, but with wings like a bat and the horns of an antelope. The natives hereabouts call these animals the Pegasi. Little is known of their habits, as they inhabit the inaccessible heights of the mountains and are rarely seen.

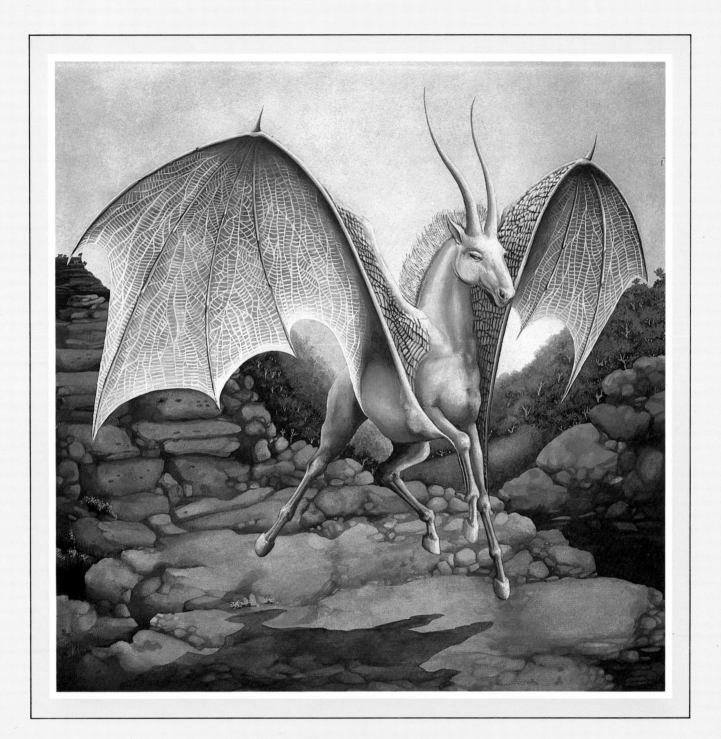

The Pegasi

Pl. XIX

DE MONOCEROTIBUS

Hac regione compluribus monocerotium generibus occurrimus, quorum aliqui non magni sunt, similes et amplitudine et forma capris vel cervis, sed uno cornu acuto media fronte eminente. hoc genus vix conspicitur quod est timidum et celer cursu.

est et genus beluarum periculosissimum, quam vivam negant posse capi. pellem armatam habet, et cornu cubitorum duum longitudine.

reges principesque magno pretio pocula ex monocerotium cornibus ficta solvunt, credentes ea contra venena esse efficaces. in pulverem cornua contrita dicuntur omnes morbos sanare.

Unicorns

In this country we encountered several species of unicorns. Some are not large, being like goats or antelope in size and form, but with a single sharp horn projecting from their foreheads. This sort are difficult to glimpse as they are timid and fleet of foot.

There is a monstrous, dangerous variety which is impossible to capture alive. It has an armoured hide and a horn of two cubits length.

Kings and nobles pay high prices for goblets carved from unicorn horns, believing them to to be proof against poisoning. Ground into a powder, the horn is said to be a cure for all ailments.

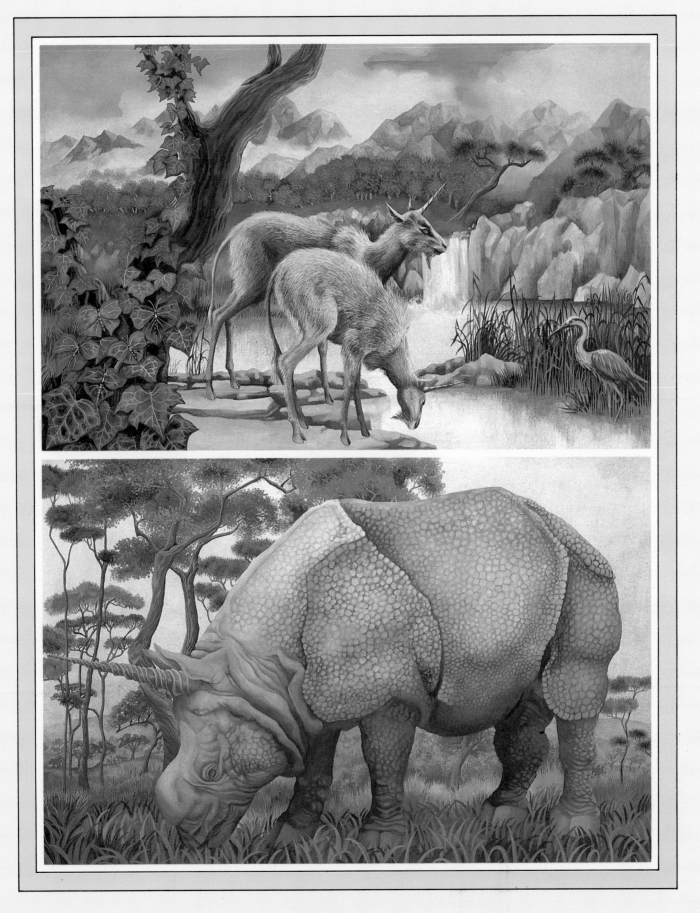

Unicorns

Pl. XX

DE AMPHISBAENA

Ad meridiem navigantes ad insulam Taprobanem pervenimus, cuius maior pars silvis inviis cooperta est. illic inesse nobis narravere incolae serpentem mirabilem nomine Amphisbaenam, quem inter arboris ramos implicatum invenimus.

anguis illa amphisbaena geminum caput habet, hoc est et a cauda; ambobus exitiale virus. quam periculosissimum est appropinquare, cum sese utraque parte movere possit, itaque summa celeritate cursum commutare.

Amphisbaenae

We sailed south to the island of Taprobane, much of which is covered by impenetrable forest. The local inhabitants described to us a peculiar snake called the Amphisbaena. We came upon this creature entwined among the branches of a tree.

The Amphisbaena is a serpent with a head at each end of its body. Both heads are armed with deadly venomous fangs. It is very dangerous to approach as it moves from either end, and consequently can change direction very quickly.

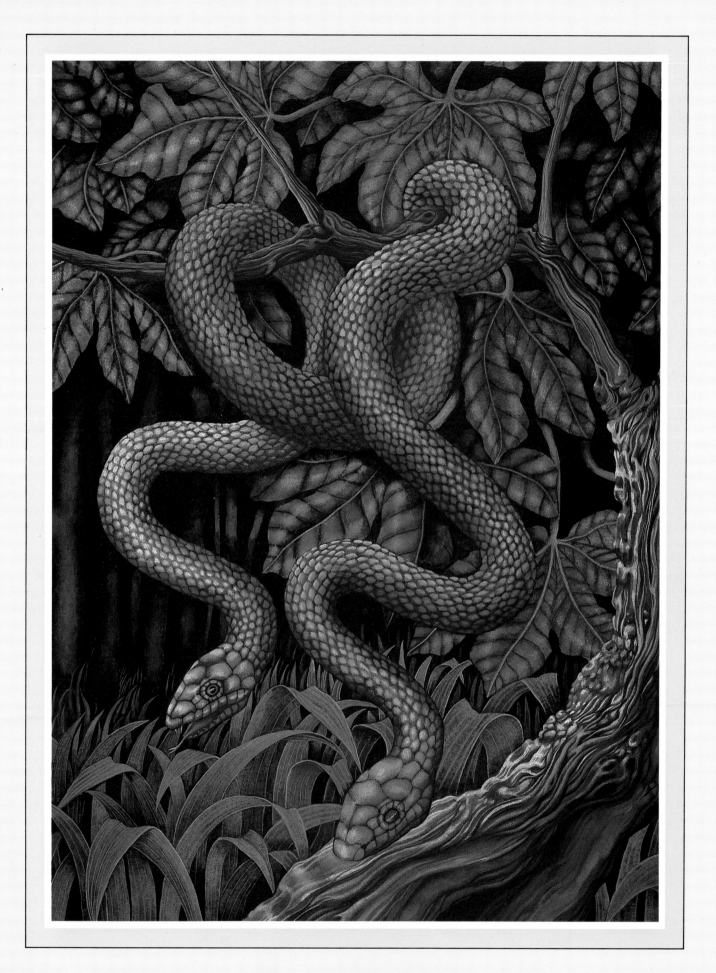

The Amphisbaena

Pl. XXI

DE VITISERPENTIBUS

Mare Indicum transiimus usque ad litus Indonesiae difficile accessu propter radices implicatas arborum apud oram crescentium. in silvam quae peninsulam cooperit aliquantum ingressi sumus.

de arboribus altissimis dependent sese vites in diversas partes moventes ac torquentes. capita et squamas serpentium praebent, duplicem naturam et animalium et herbarum habentes. locus metuendo strepitu sibilantium resonat.

Snake Creepers

We crossed the Indian Ocean to the coast of Malaya, which is difficult to approach on account of the tangled roots of trees growing in the water's edge. We made our way for a short distance into the forest which covers the peninsula.

The trees are of great height and hung about with creepers which writhe and move about in all directions. They have the heads and scales of snakes, being part animal and part vegetable. The place is filled with the fearful sound of their hissing.

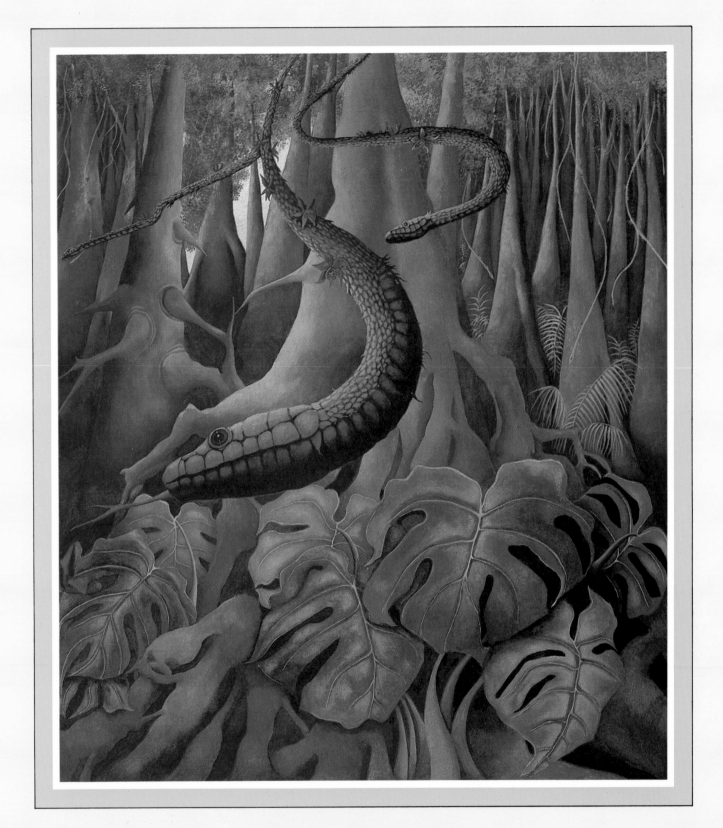

Snake Creepers

Pl. XXII

DE HERBIS ANIMALIBUS VESCENTIBUS

Aliquot herbarum ungues corniculaque sicut polypi bracchia habent, ut lacertas, aves, et talia parva animalia quibus vescentur implicent. est et herba circa septem cubitorum crassitudine, quae validissima bracchia habens et magna animalia praedam suam facere solet. quibus incolae hostiam humanam immolant, ut numina deorum silvae placent.★

Flesh-Eating Plants

Some of the plants have claws and tentacles in order to ensnare lizards, birds and small creatures which they feed upon. There is a plant some seven cubits in diameter with very strong tentacles which preys on large animals. The natives make human sacrifices to them so as to placate the spirits and gods of the forest.★

★Note: The exact wording of this is uncertain due to the condition of the manuscript. An alternative reading could be 'The natives present strangers to them (the plants) as they believe them to be the gods of the forest'. (quibus incolae hospites inducunt, quia creditur silvae deos esse.)

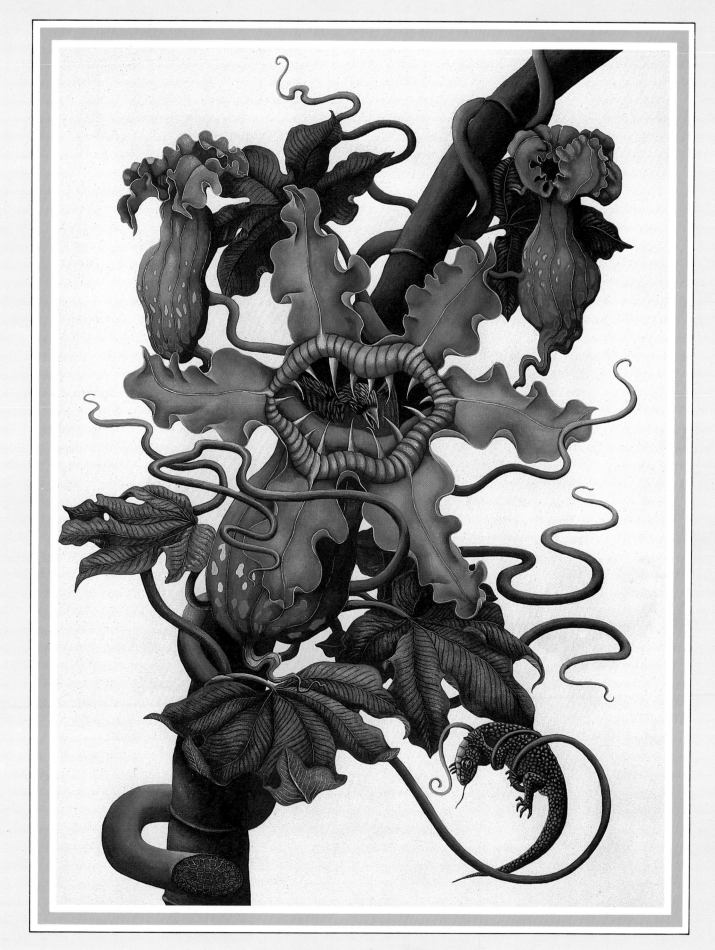

Carnivorous Plant

Pl. XXIII

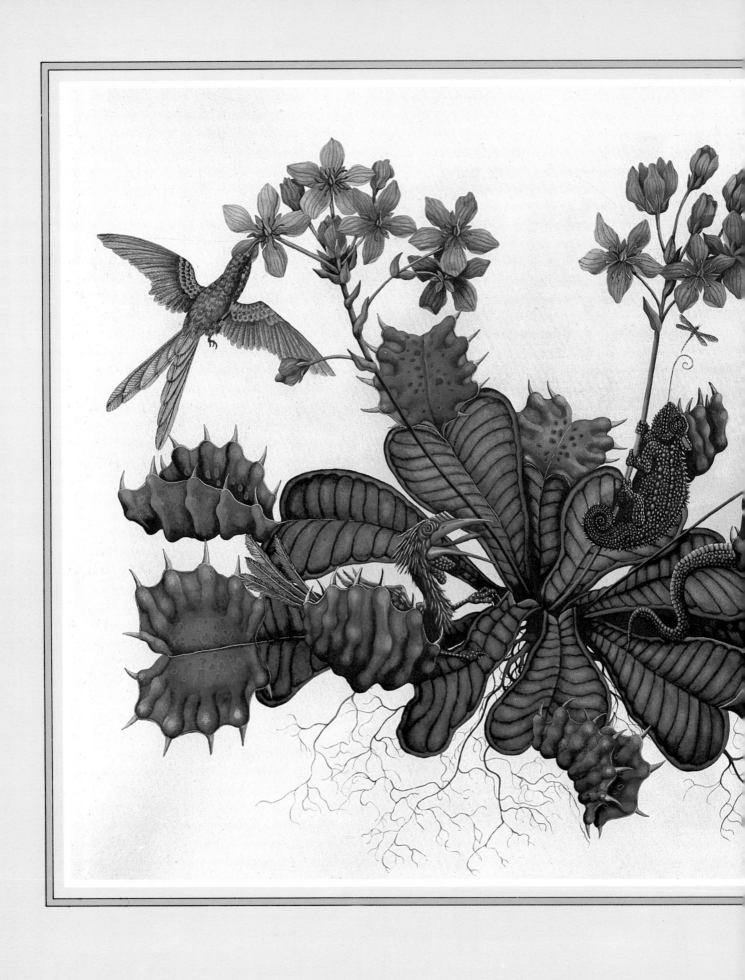

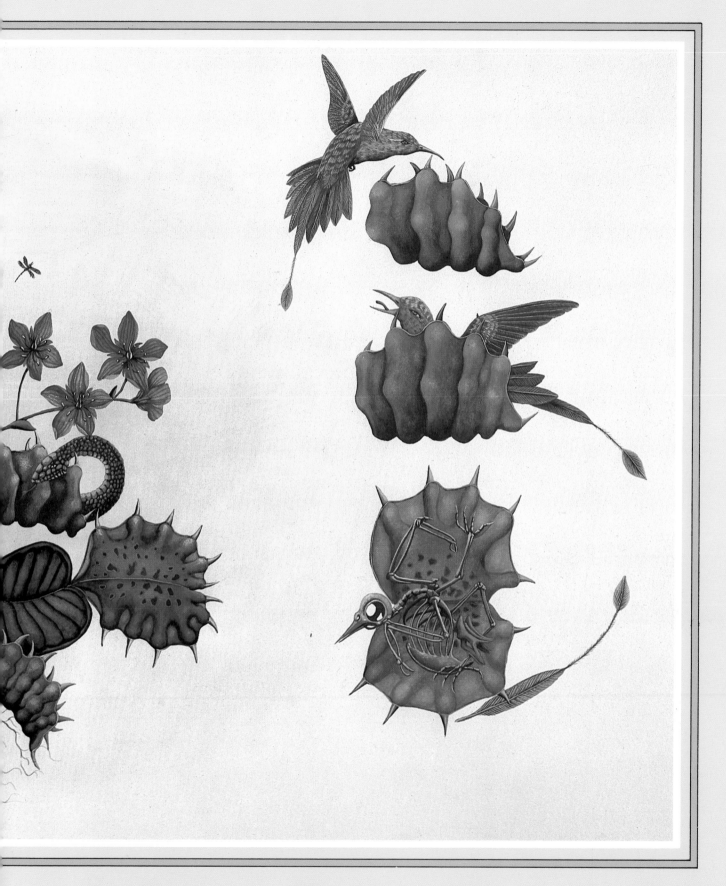

Carnivorous Plant

Pl. XXIV

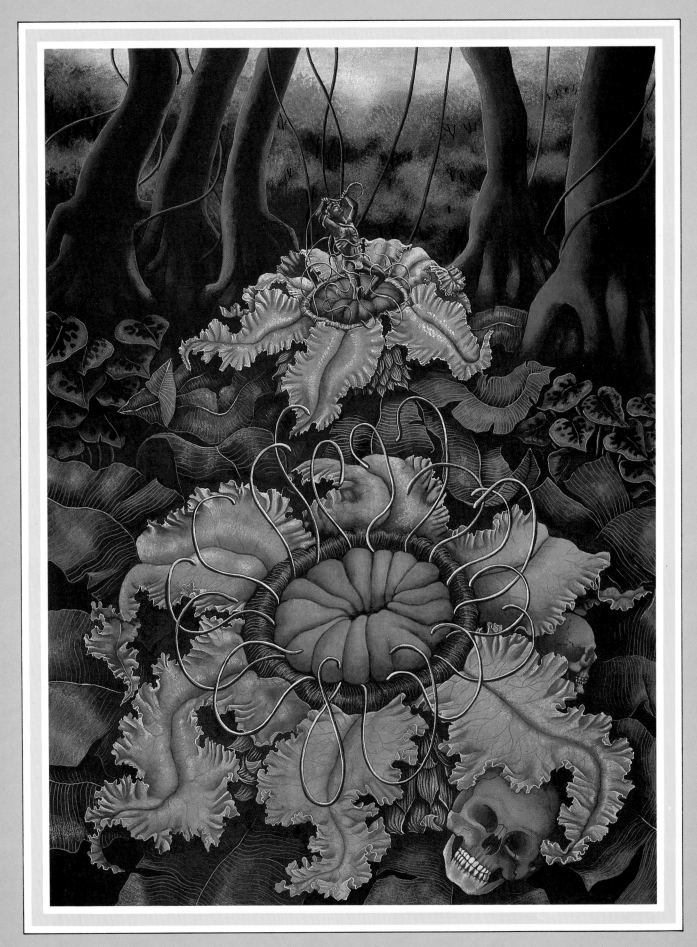

Man Eating Plant

Pl. XXV

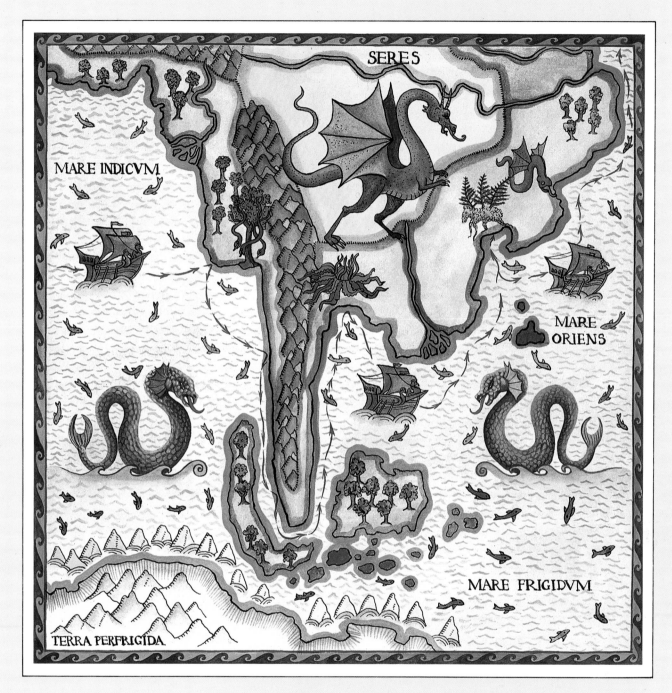

Map Of
CHINA

DE BAROMEZO

Tum ad regionem merionalem Orientis ulterioris iter fecimus. ibi invenimus Baromezum vel Holeragnum, quod aliud exemplum est animalis cum herba coniuncti. radicibus in tellure inhaerent sed formam agnorum habent. filices e tergo eminent.

Baromezus velut herba augetur donec agni adoleverint, cum graminibus quae eos circumdant pascuntur. radicibus tamen in uno loco actis, mox fame pereunt. obnoxii sunt quoque lupis, qui eis edendis delectantur.

Barometz

We journeyed then to the southern region of China. Here we found the Barometz or Vegetable Lamb which is another example of the union of the animal and vegetable kingdoms. They are rooted in the ground and have the form of lambs with ferns sprouting from their backs.

The Barometz grows like a plant until the lambs have reached maturity, when they crop the surrounding grasses. However, being rooted in one place, they soon perish from lack of nourishment. They are also easy prey for wolves, which delight in feeding on them.

The Barometz

Pl. XXVI

DE DRACONIBUS ORIENTALIBUS

Multa genera draconum Orientem incolunt; in fluminibus, montibus, aere habitant. quorum nonnulli sunt magnitudinis immanis, complura milia passuum longi. ergo perniciosissimi sunt.

Orientales credunt eos vim magicam possidere et conspici celarive, quotiens velint, posse. alii pinnati non sunt; possunt tamen volare. alii nullos aures habent sed cornibus audire possunt.

draconum dentes, ossa, saliva creduntur virtutes medicinales habere.

dracones ipsi sub imperium regum immortalium cadunt qui secum sine verbis procul colloquuntur.

Eastern Dragons

A great variety of dragons live in China, inhabiting the rivers, mountains and skies. Some are of such gigantic proportions, being several miles in length, that they are capable of great destruction.

The Chinese believe that they have magical powers, and are able to become invisible and visible at will. Some, which do not possess wings, are yet able to fly. Others have no ears but are able to hear with their horns.

Dragon's teeth, bones, and saliva are believed to have medicinal qualities.

The dragons are ruled over by kings who are immortal, and who communicate with each other over great distances without the use of words.

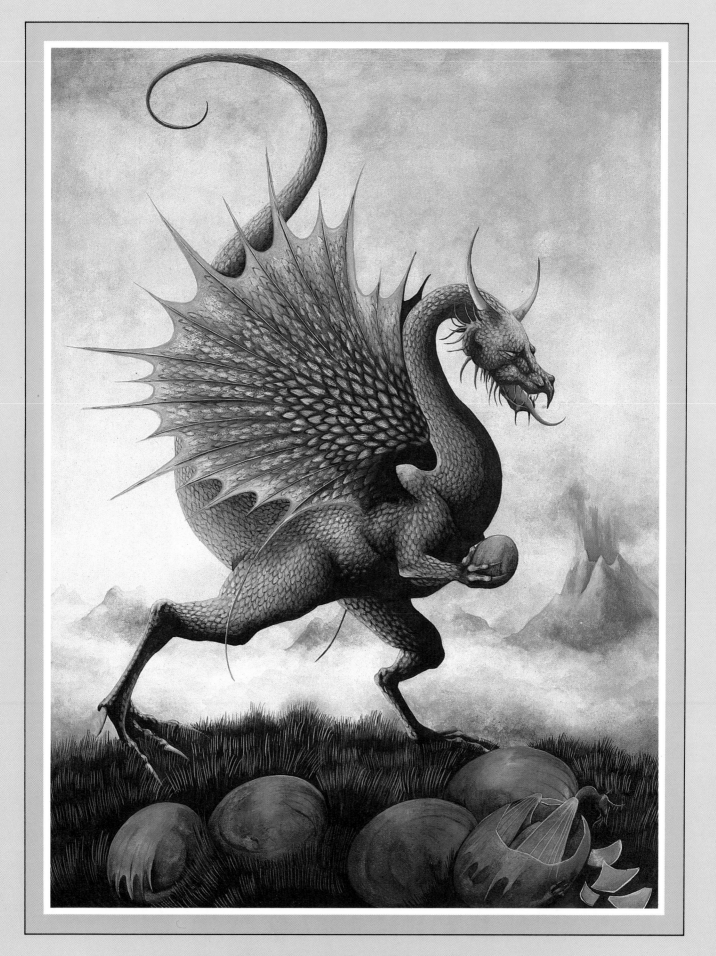

The Eastern Dragons

Pl. XXVII

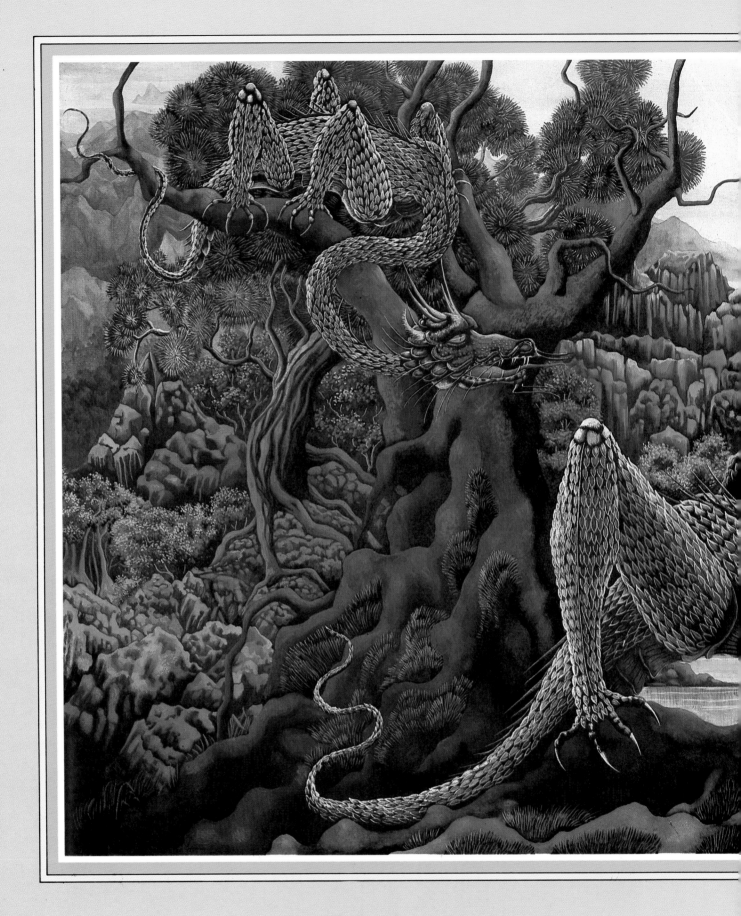

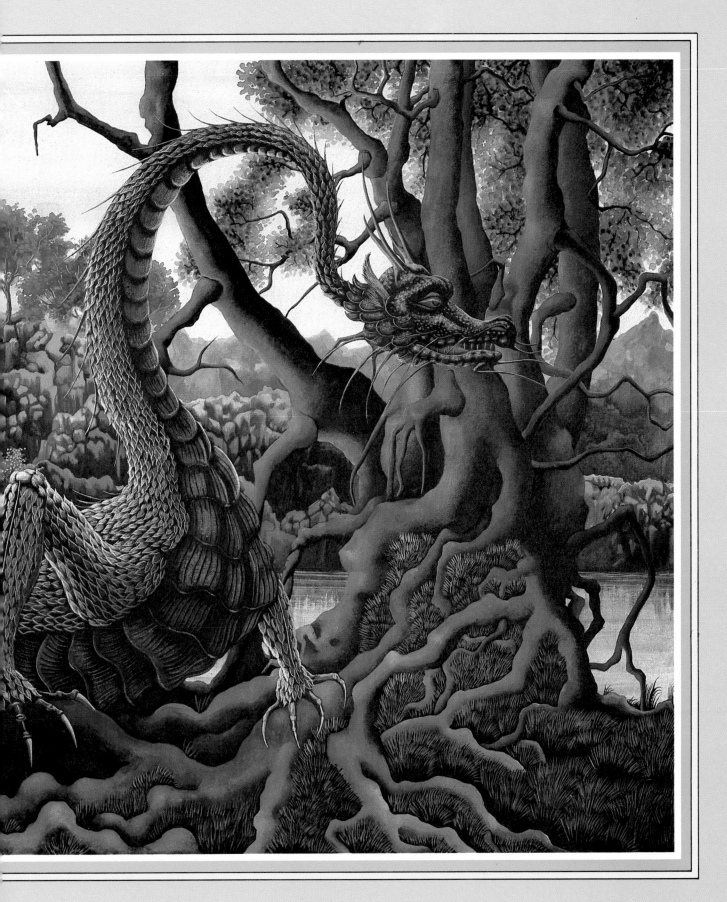

Eastern Dragons

Pl. XXVIII

DE PISCE HUA

Orientales ingenii mitis et impigri sunt. quorum tamen terra tam procul a reliquis hominibus abest ut lingua institutaque aegre intellegi possint. auspicia et superstitiones magni faciunt.

in una regione incolae se parabant ad siccitatem sustinendam quam praedixerat aspectus in stagnis et fluminibus piscis Huae; hoc est animal volatile, cuius pars piscis, pars anguis est.

Hua Fish

The Chinese people are mild and industrious in character, yet their land is so distant from the rest of mankind that their language and customs are difficult to understand. They attach great importance to omens and superstitions.

In one area the people were preparing for a period of drought which had been forecast by the appearance, in the ponds and rivers, of the Hua Fish, which is a flying creature, part fish and part snake.

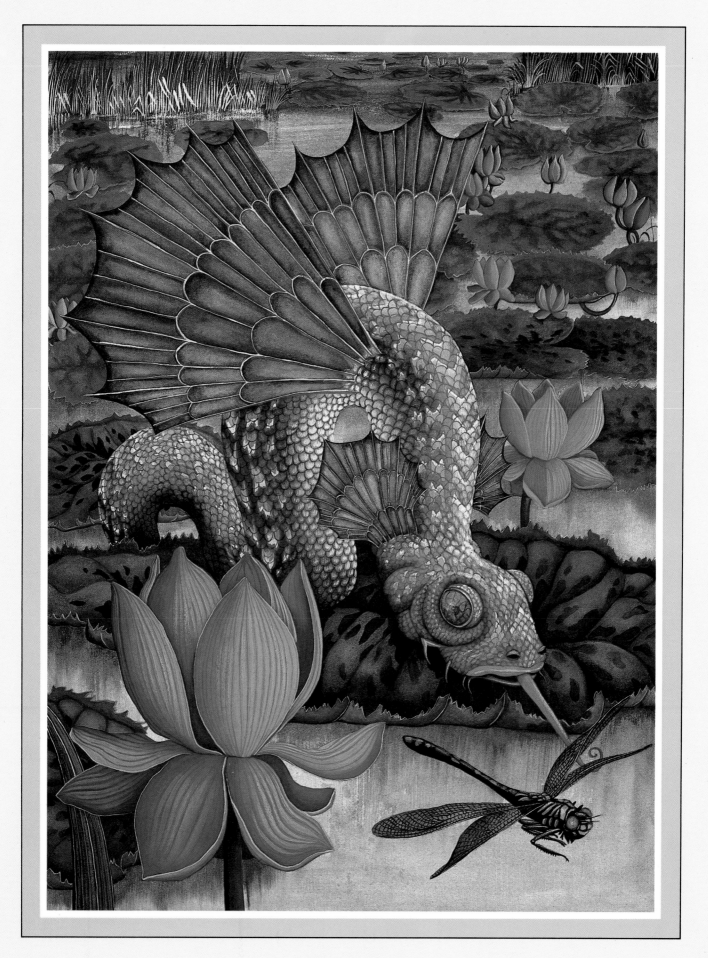

Hua Fish

Pl. XXIX

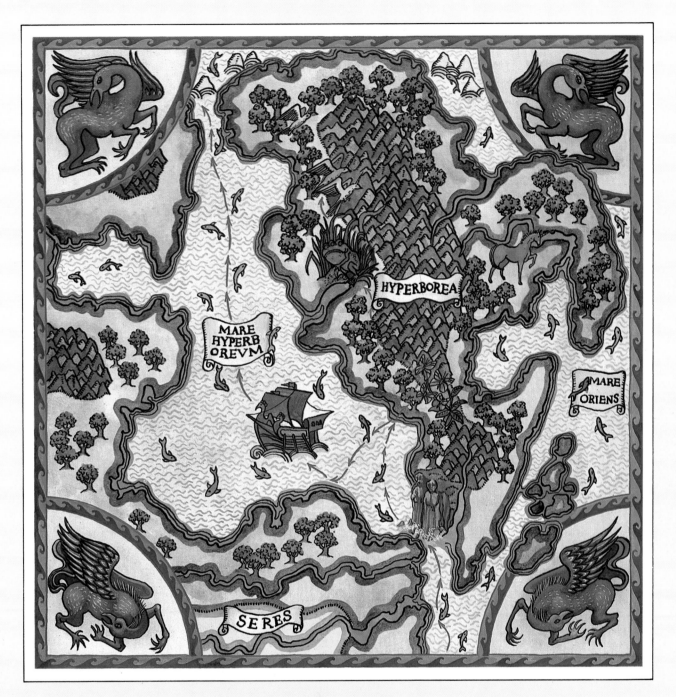

Map Of
HYPERBOREA

DE TERRA HYPERBOREA

Aditui angusto qui ad mare Hyperboreae ducit conterminae sunt rupes arduae, mire et similiter mulieribus figuratae. nocte dicuntur vivescere et naves praetereuntes delere.

★ Hyperborea est terra amoenissima et uberrima. incolae ad extremam senectutem attingunt et insignes sunt miraculis quibusdam fabulosis.

in hac longinqua terra sol modo semel quotannis media aestate oritur et semel media hieme occidit. populus mane serit, meridie messem facit, fruges ab arboribus solis occasu carpit, in antra per noctem se recipit. primitias Apollini dedicare solet.

Hyperborea

Tall cliffs flank the entrance to the straits leading to the sea of Hyperborea. They are curiously formed, being like human women. It is said that at night they take life and destroy the ships that pass.

*Hyperborea is a most pleasant, fruitful land. The inhabitants live to extreme old age, and are famous for legendary marvels.

In this remote land the sun rises but once a year, at midsummer, and sets once, at midwinter. The people sow in the morning periods, reap at midday, pluck the fruit from the trees at sunset, and retire into caves for the night. They make offerings of the first fruits to Apollo.

*Note: In the 'Natural History,' (Book IV, chapter XII) Pliny describes Hyperborea as being a utopia in which "all sorrow is unknown." The inhabitants do not die naturally, but choose their time of death, which they celebrate with banqueting and rejoicing, terminating their lives by leaping from a certain rock into the sea.

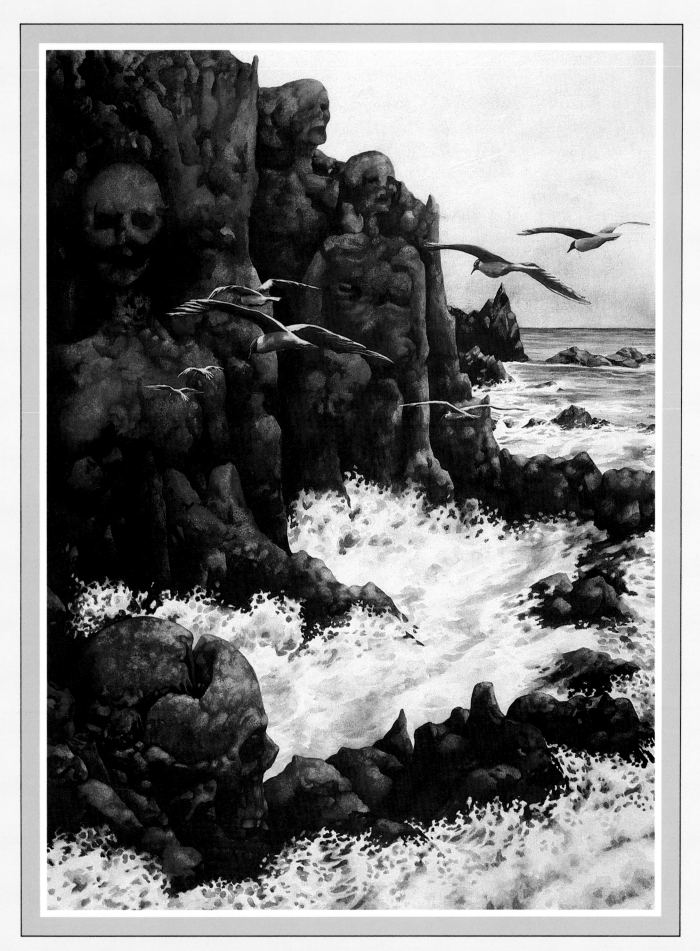

Hyperborea

Pl. XXX

DE INSECTIS QUAE AB HERBIS GENERANTUR

Insecta plerumque ex ovis gignuntur quae vermiculi fiunt. haec multos dies avide vescuntur. postea cutibus duris tegi incipiunt; deinde chrysalides vocantur. aliquot post diebus amplius e cutibus erumpunt et adulta evolant.

insecta autem animadversa sunt aliis modis saepe generari. imber cum in terram incidit efficere potest ut frequentes muscae aliaque insecta sua sponte oriantur. interdum lignum putrefactum aut loca umida pariunt genera quaedam; ita oriuntur Capriblatta et tabanus.

in montibus Hyperboreis aer plenus est tamquam nubibus insectorum multifariorum, praecipue papilionum. haec simpliciter generant herbae insolitae quibus clivi vestiuntur.

Insects Generated By Plants

Insects are usually born from eggs which develop into grubs. These feed voraciously for several weeks, after which they grow hard skins and are then known as chrysalids. After some further weeks they burst their skins and fly out as adult insects.

However, it has been noticed that insects are often generated in other ways. The effect of rain on the earth is sufficient to cause plagues of flies and other insects to occur spontaneously. Sometimes rotting wood or damp places become the parents of certain species; such is the case with the goat moth and the horse-fly.

In the mountains of Hyperborea the skies are filled with clouds of many different sorts of insects, particularly butterflies. These are generated directly by the unusual plants that cover the slopes.

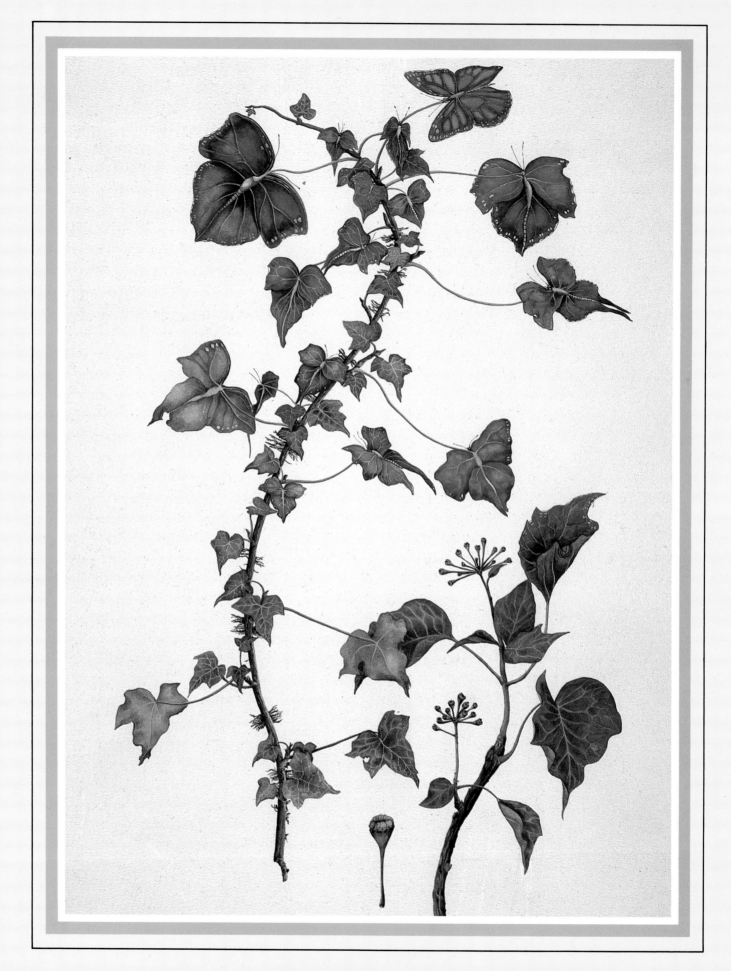

Butterfly Plant

Pl. XXXI

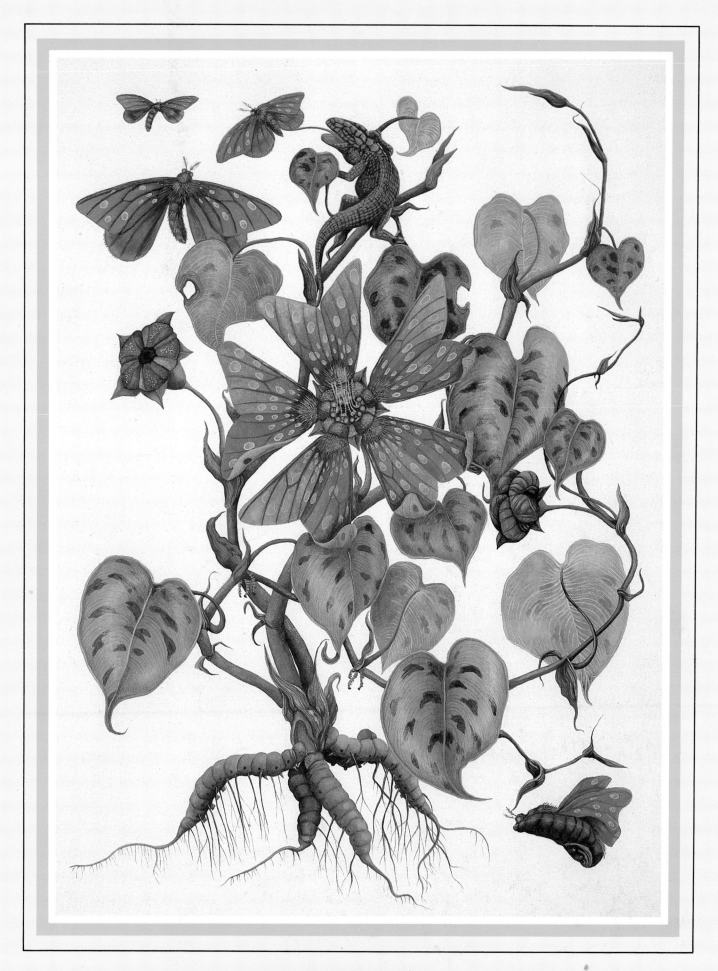

Moth Plant

Pl. XXXII

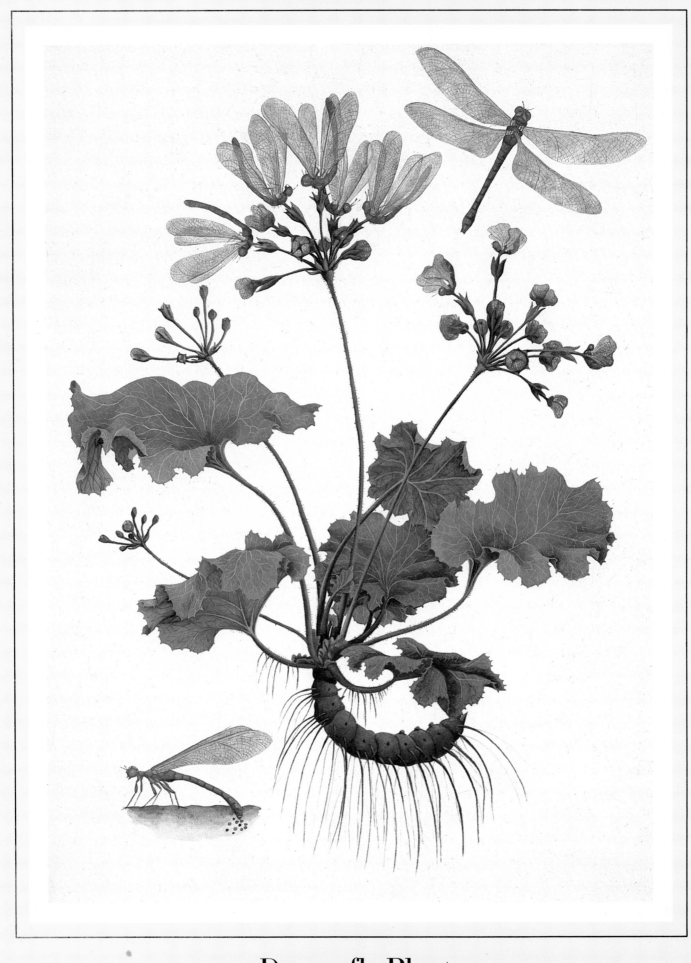

Dragonfly Plant

Pl. XXXIII

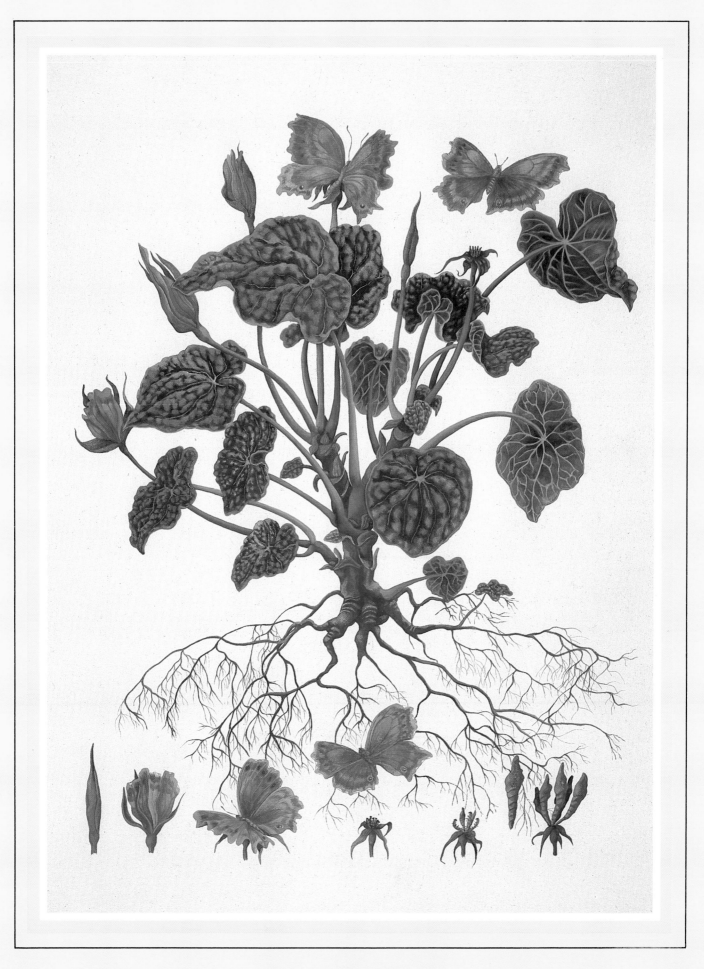

Butterfly Plant

Pl. XXXIV

DE RANIS HYPERBOREIS

Sunt flumina quattuor principia quae per pascua ubera Hyperboreae fluunt. aquae plenae piscibus sunt et ripae abundant ranis quas incolae iucundissimum alimentum esse ducunt.

eae quae bicipites sunt imprimis exquiruntur, quippe quae putantur fortunae et fertilitati prodesse.

Hyperborean Frogs

There are four main rivers flowing through the lush pastures of Hyperborea. The waters are full of fish and the banks contain an abundance of frogs which the inhabitants consider highly palatable.

Varieties which have two heads are particlarly sought, as they are thought to promote luck and fertility.

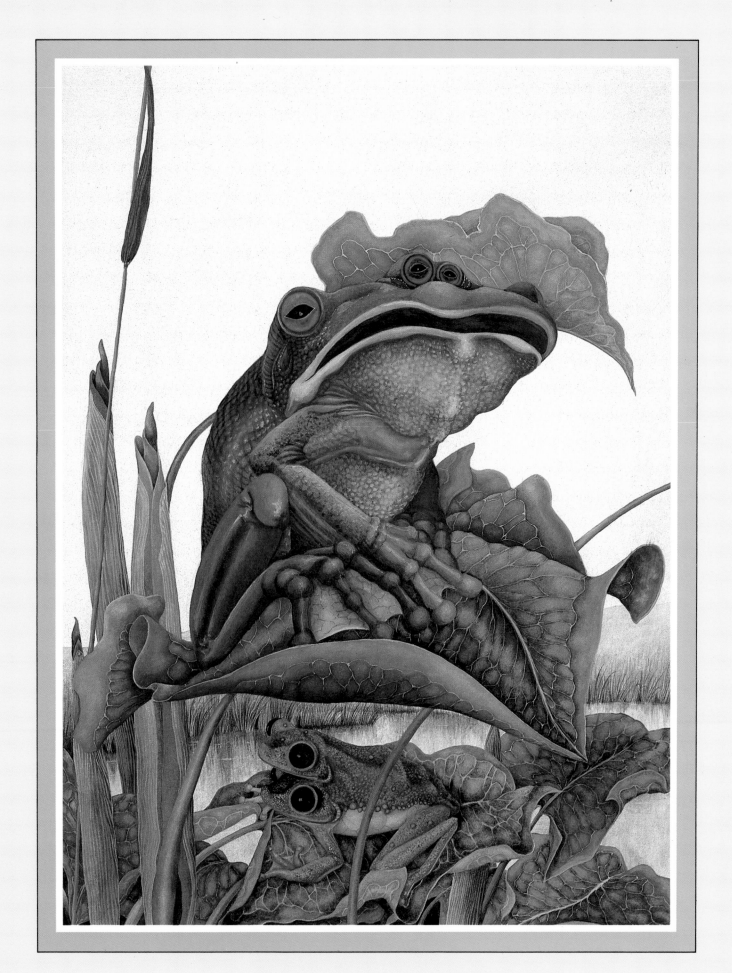

Hyperborean Frogs

Pl. XXXV

DE SILVIS HYPERBOREIS

Aliquae Hyperboreae partes vestitae sunt silvis densissimis. arbores vetustae saepe formam miram possident, haud dissimilem monstris, draconibus, hominibus.* ferunt monocerotes has silvas incolere. nos tamen hoc confirmare non potuimus.

notabile est quod quaedam ex avibus uno cornu sunt, perinde ac monocerotes Indici.

The Forests Of Hyperborea

Parts of Hyperborea are covered by dense forests, with ancient trees which are often grotesquely shaped, resembling the forms of monsters, dragons and men.* It is said that unicorns inhabit these forests, although we were not able to verify this.

Curiously, certain of the birds are armed with single horns, like those of the Indian unicorns.

*Note: The meaning of this sentence is speculative, as only fragments of words are decipherable. It could read: '…containing the spirits of corrupt serpent men, monsters in ancient times.'

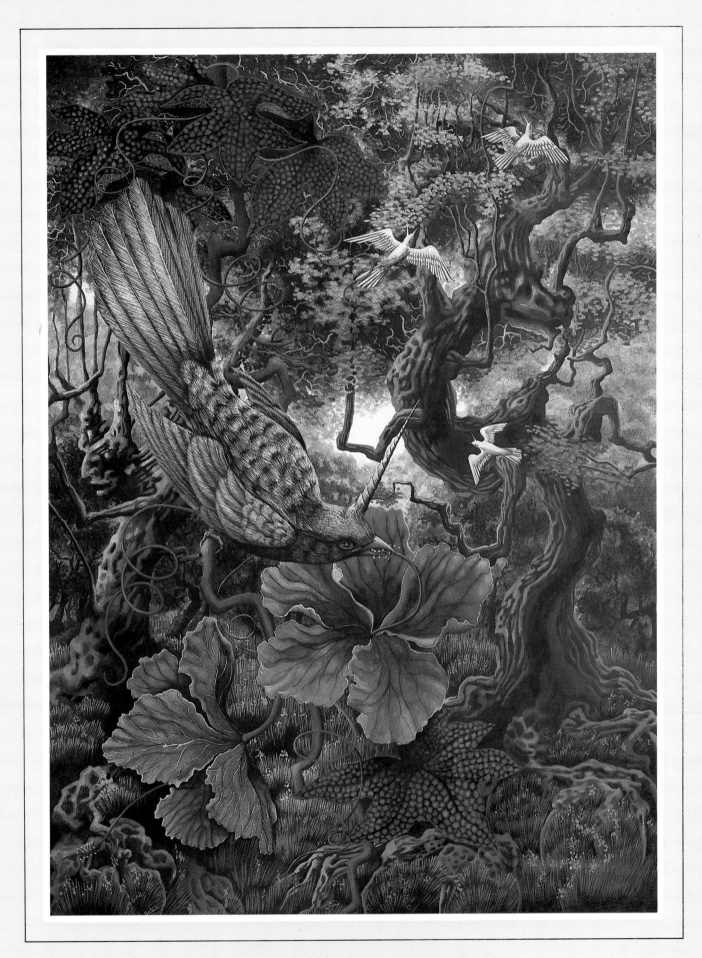

Hyperborean Birds

Pl. XXXVI

Inde mare Hyperboreum transiimus ad continentem Asiam reveniendi causa. hic aliquamdiu mansimus ut navem nostram pararemus ad iter in oceanum gelidum septentrionalem faciendum.

terrae quae ad septentriones pertinent nive semper obrutae sunt, sed in his locis ver aderat atque nives satis liquerant ut paterentur crescere muscos, herbas, flores et parva animalia avesque nasci. ibi genus, ut ante, animadvertimus in quo coniuncta sunt animal et herba. hoc est graminis genus cuius flores sunt aves parvae et pictae.

Bird Plants

We crossed the Hyperborean Sea to return to the mainland of Asia, where we remained for a time in order to prepare our ship for the journey into the freezing ocean of the north.

The lands of the north are perpetually snowbound, but here it was springtime and the snows had melted sufficiently to allow for the growth of mosses, plants and flowers and the breeding of small animals and birds. Here again, we observed a species which combines the animal and vegetable worlds. This is a variety of grass with flowers which take the forms of small brightly coloured birds.

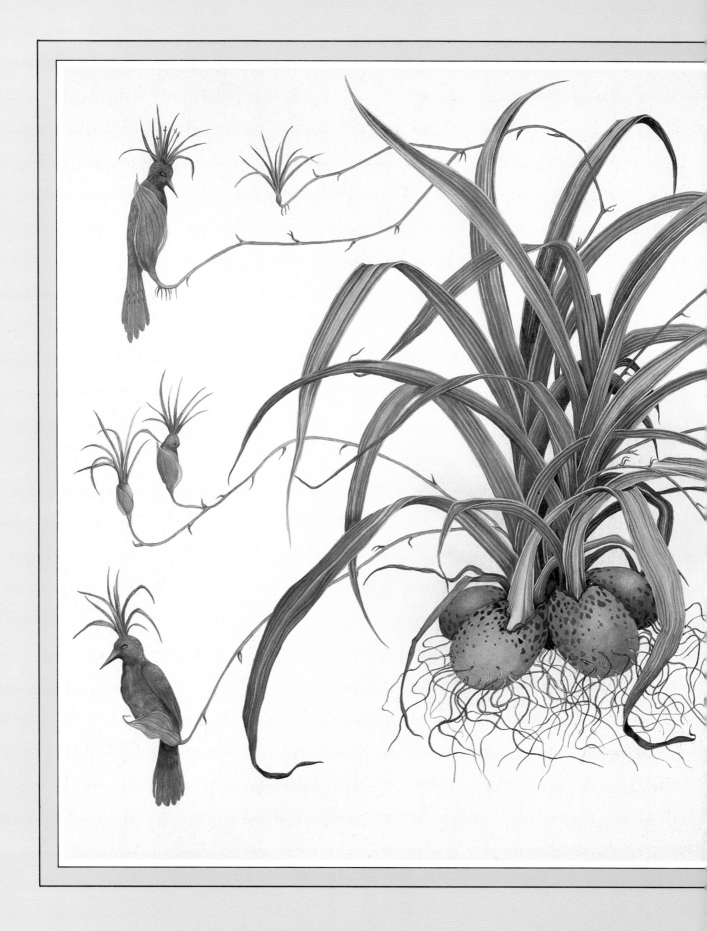

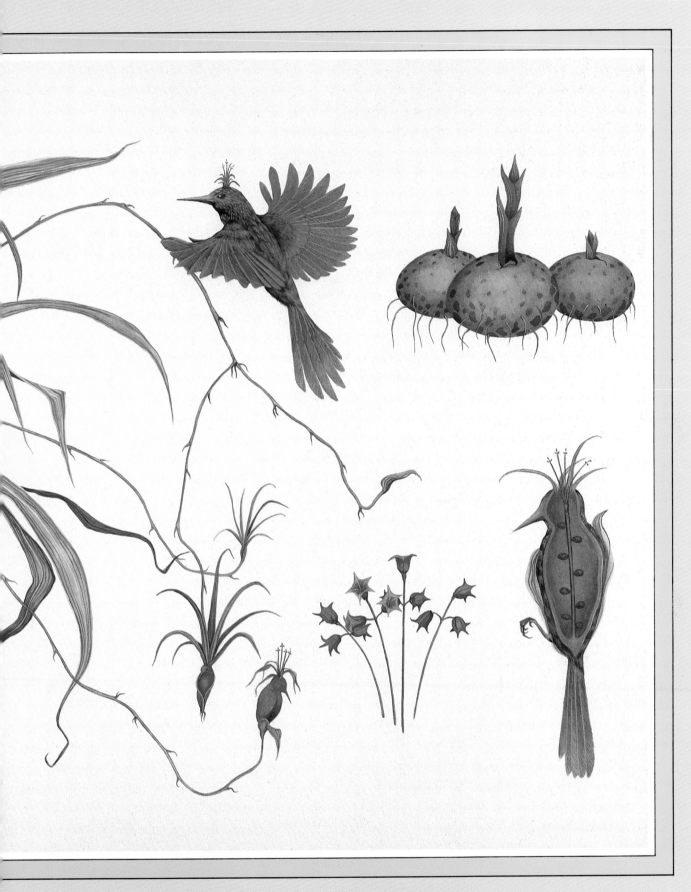

Bird Plant

Pl. XXXVII

DE PERYTONIBUS

Dum in septentrionali parte extremi Orientis manemus, in altissimos montes ascendimus ut Perytones ibi videremus.★

haec animalia crures et capita velut cervi, alas et corpora velut aves habent. maxime mirandum est quod umbras humanas pro suis deiciunt. si quis eorum hominem necat, creditur umbram eius veram dis reddi.

apud Graecos scriptores relatum est Perytones in Atlantide sedem antiquitus habuisse.

Perytons

During our stay in Northern China we climbed high into the mountains in order to see the Perytons★ there.

These creatures have the heads and legs of deer and the wings and bodies of birds. Most curious is the fact that they cast the shadows of men instead of those of their own bodies. It is thought that if one of them succeeds in killing a man its genuine shadow is returned by the gods.

According to the Greeks the Perytons had their original dwelling in Atlantis.

★Note: Information about the Perytons, taken from an unknown Greek source, is quoted in a treatise by a 16th-century Rabbi from Fez (Jakob Ben Chaim). Unfortunately, this document, which had been in the library of the University of Dresden, disappeared during the Nazi regime. Until recently it had been believed that this was the only copy in existence, however, it is now hoped that fragments found in the 'Glastonbury Library' are contemporary copies of the Rabbi's work.

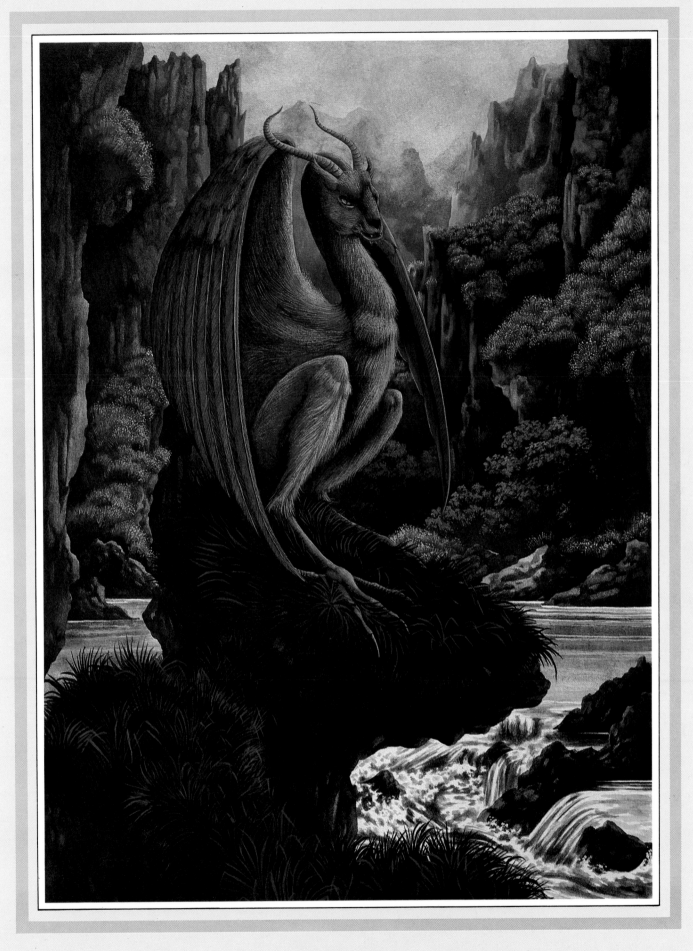

Perytons

Pl. XXXVIII

DE HIPPOGRYPHIBUS

Deinde iter difficile circum oram septentrionalem per oceanum gelidum suscepimus.

ager sterilis est, frigidissimus et caligine saepe adfectus. absunt viventes, praeter paucos homines inculti generis ac mira animalia. hic vidimus illos rarissimos Hippogryphes, qui sunt hybridae gryphibus et equi parti.

Hippogriffs

We then began the difficult journey around the northern coast of Asia through the frozen ocean.

The land is barren, being intensely cold and often in darkness. There are no living creatures, save a few races of wild men and monstrous creatures. Here we saw the very rare Hippogriffs, which are hybrids of griffons and horses.

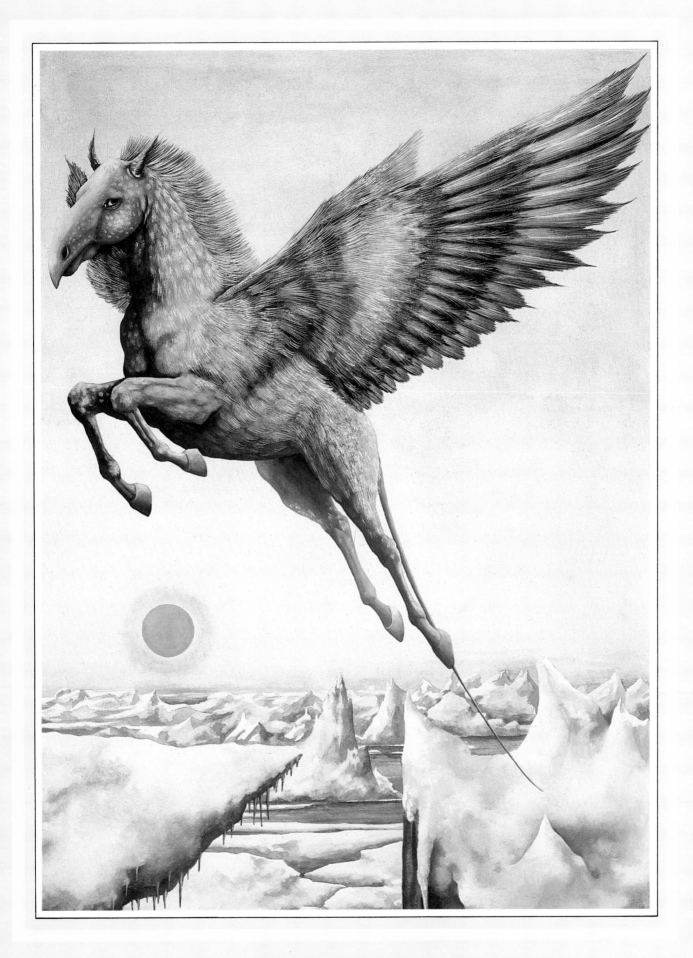

The Hippogriffs

Pl. XXXIX

Navis nostra aestibus secundum litus celeriter vecta est.

genti venatorum palantium prope ostium fluminis glaciati obviam ivimus. quaedam e feminis habent potestatem oculis fascinandi et artes magicas exercendi, quibus utuntur ad suos in illo infecundo agro defendendos. hae feminae acie sua fascinare vel etiam interficere possunt. nam habent in altero oculo duplicem pupulam, in altero simulacrum equi.

apud Apollonidem traditur tales mulieres Bitias nomine in Scythia, alios eadem potentia in Ponto habitare.

Women With The Evil Eye

The currents bore our ship swiftly along the coast. We encountered a tribe of nomadic hunters near the mouth of a great river of ice.

Certain of the women folk possess the evil eye and are powerful practitioners of the magical arts, which they use for the protection of their people in these barren lands. These women are able to bewitch, or even kill, with their stare. They have in one eye a double pupil and in the other the likeness of a horse.

Apollonides reports women of this kind called the Bitiae in Scythia, and other people with the same powers who live in Pontus.

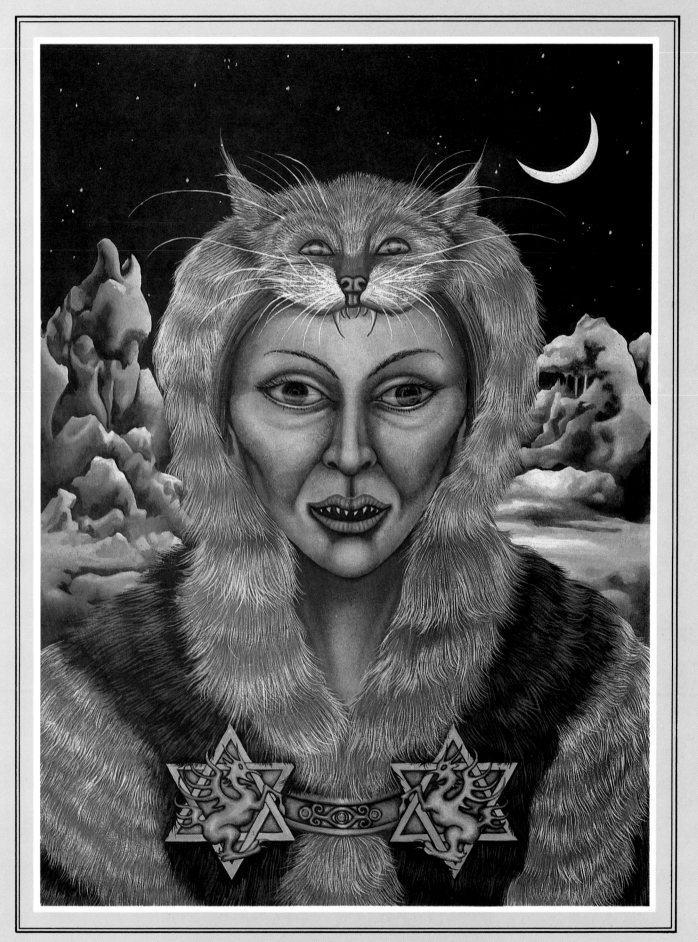

Women With The Evil Eye

Pl. XL

Tandem appropinquabamus finibus Scythiae qui vergunt ad septentriones. hi sunt nive obruti sed vitae patientiores.

haec loca incolit natio hominum volantium. sunt eis alae unguesque velut avibus; in speluncis habitant, cervis et piscibus praedantur. timidi erant, neque tamen erga nos inimici sed nostro aspectu attoniti, quoniam parum coniuncti sunt cum ceteris hominum populis.

Flying Men

At length we approached the lands of Northern Scythia that are snowbound but are better able to support life.

A race of flying men dwell in these parts. They have the wings and talons of birds, inhabit caves and prey on deer and fish. They were shy but not inhospitable towards us and surprised at our appearance, since they have little contact with the other races of mankind.

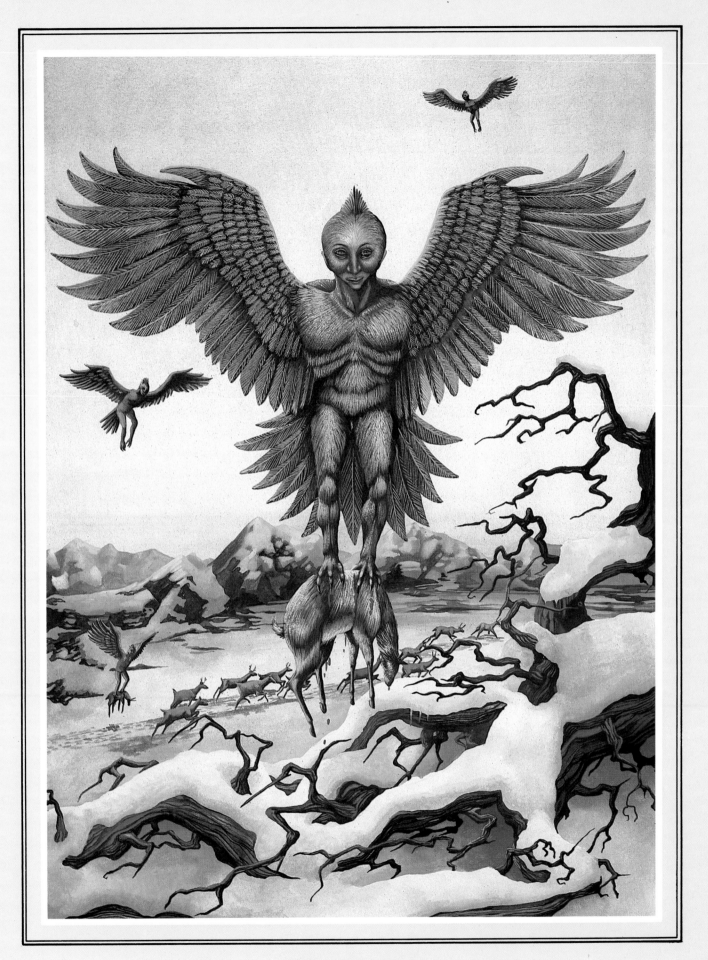

Flying Men

Pl. XLI

DE POLYPIS

Inde per freta angusta navigavimus in mare Germanicum; sparsae sunt quaedam parvae insulae, quarum complures fluitare videntur. sunt enim, si propius inspiciantur, animalia viva.

haec sunt pisces polypodii, terribiles aspectu, possidentes multiplicia capita una cum pedibus tenacissimis qui possint circumdare vel maximas naves. umorem atrum emittere consueverunt qui nigrat venenatque aequora maris.

tum ad oram Germaniae septentrionalis pervenimus.

Krakens

We passed through narrow straits into the Baltic Sea which is scattered with small islands. Some of these appear to be floating and are, on closer examination, found to be living creatures.

These are the Krakens. They have a terrifying appearance, with multiple heads and strong tentacles capable of encompassing the largest ships. They are in the habit of discharging a dark liquid which blackens and poisons the waters of the sea.

We came then to the coast of North Germany.

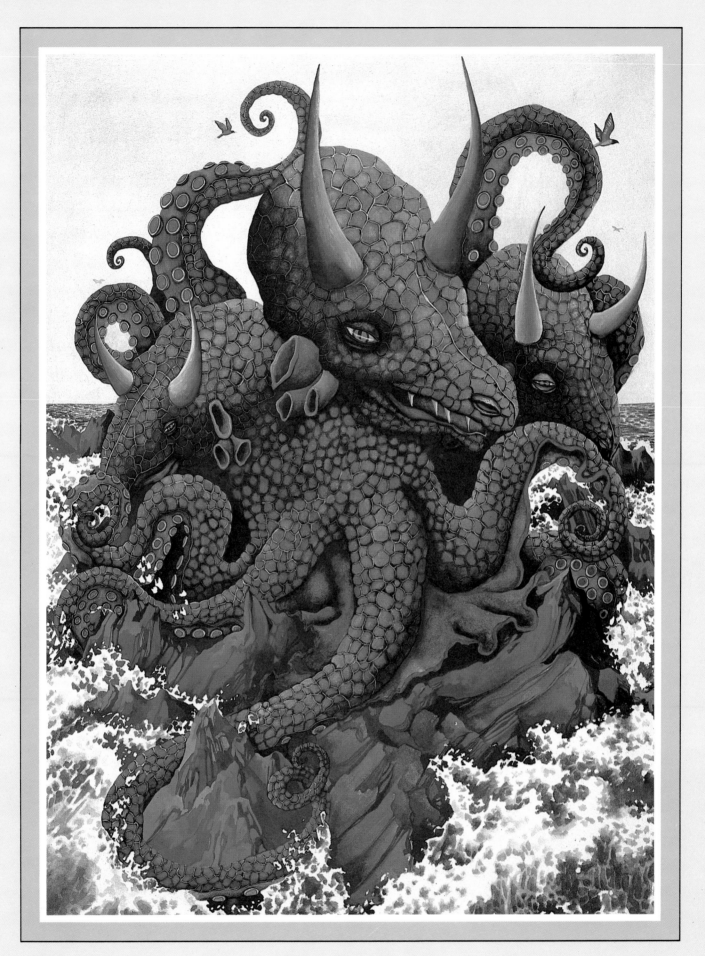

The Kraken

Pl. XLII

DE HOMINIBUS AURITIS

Sunt multae et parvae insulae contra Germaniae litus sitae, quarum nonnullas inhabitat gens piscatorum. hi Auriti nominantur propter aures magnitudine praeter naturam, ita ut tota corpora operiant. sunt igitur acerrimi auditus; etiam pisces sub mari audire possunt.

All Ears

There are many small islands situated off the coast of Germany. Several of these are inhabited by a tribe of fishermen called the All Ears, whose ears are of such abnormally large dimensions that they cover their whole bodies. As a consequence, they have extremely sharp hearing, being able to hear even the fishes beneath the sea.

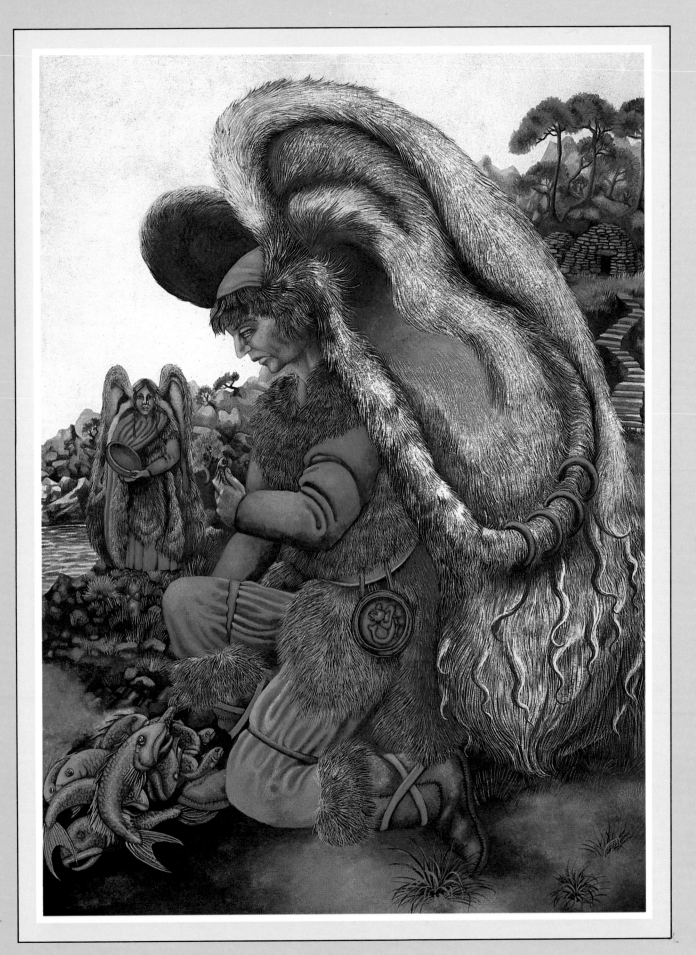

All Ears

Pl. XLIII

DE HERBIS MAGICIS

In silvis Germanicis habitant ei qui artes magicas exercent. hi venefici colunt et carpunt quasdam herbas quae necessariae sunt ad incantamenta et medicamenta paranda.

Mandragoras propter potentiam magicam maxime laudatur. quae herba prope humum viget et flores purpureos bacasque flammeas profert. formam humanae similem habent radices, quorum albi viriles, nigri feminei sunt. tam exitialis est eorum potestas ut canes periti ad herbas effodiendas adhibentur.

Dracontium paene eadem vi magica medicinali praeditum est. radices formam draconum parvorum habent, sucusque usurpatur loco sanguinis veri draconis.

orchis quaedam etiam in silvis carpitur, quae orchis Harpuiae vocatur, quia flosculi forma capiti unguibusque Harpuiae similes sunt.

Magical Plants

In the German forests dwell practitioners of the magical arts. These witches cultivate and gather certain plants which are necessary in the preparation of their spells and potions.

The Mandrake is highly praised for its magical properties. This plant grows close to the ground and bears violet flowers and orange berries. The roots are shaped like human beings, the white roots being male, the black female. So deadly is their magic that trained dogs are employed to dig up the plants.

Dragonium is a plant similarly endowed with magical and medicinal properties. The roots are shaped like small dragons, and the sap is used as a substitute for genuine dragon's blood.

A particular orchid is also gathered in the forests. This is called the Devil's Orchid as its petals are shaped to resemble the heads and claws of devils.

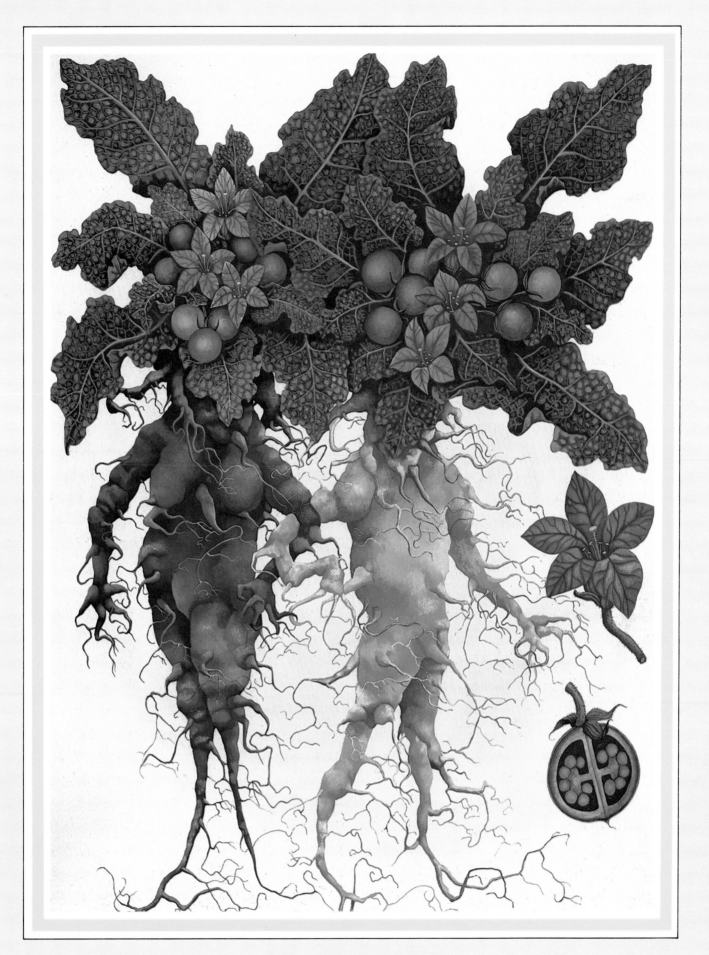

The Mandrake

Pl. XLIV

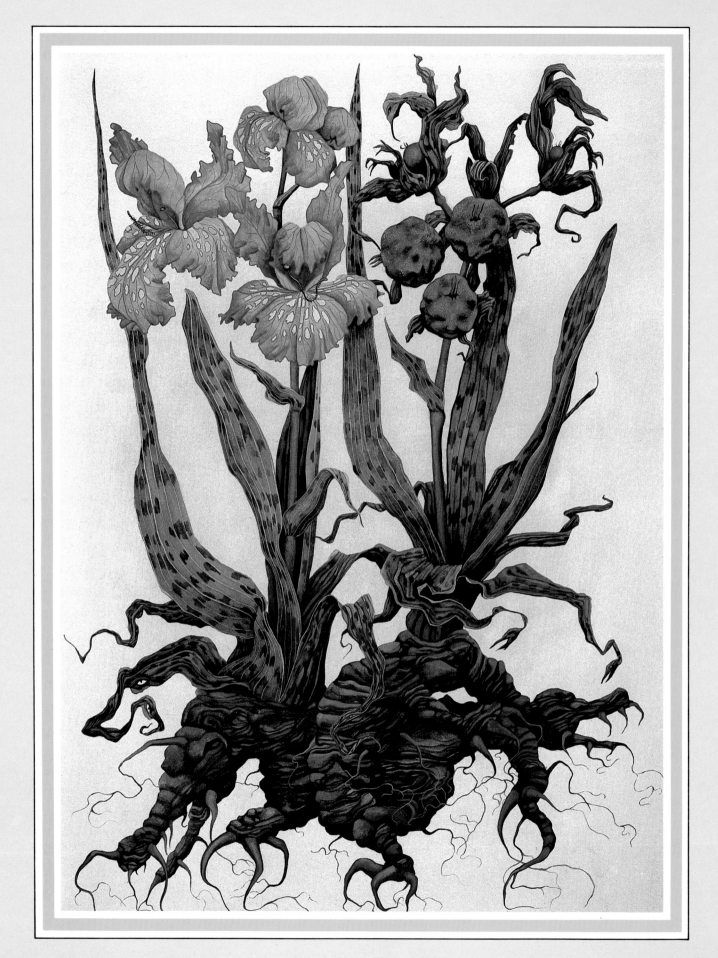

Dragonium

Pl. XLV

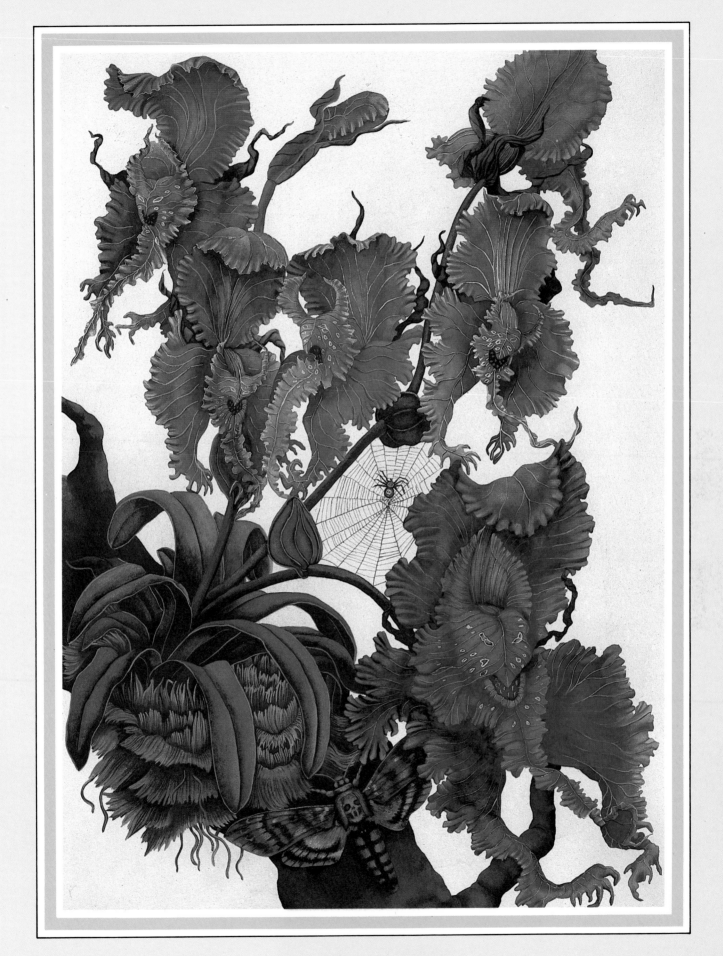

Devil's Orchid

Pl. XLVI

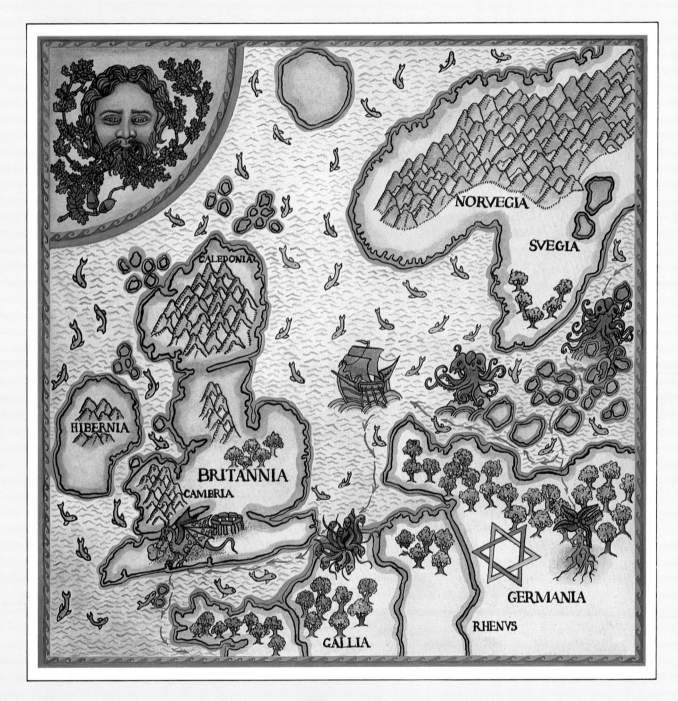

Map Of
BRITAIN

DE HYDRA

Itaque ad insulam Britanniam contendimus. prope Gallicas oras invenimus monstrum quod multa capita possidebat.

capita et colla saepta sunt magna concha. in quam animal se recipit et eo consilio celat ut praedam ex improviso adoriatur. simillimum est illi Lernaeae Hydrae quacum Hercules inter tot res tam bene gestas pugnavit.

The Hydra

We made our way towards the island of Britain. Close to the shores of France we came upon a monstrous many-headed being.

The heads and necks are enclosed in a large shell, into which the creature withdraws and remains hidden in order to spring suddenly upon its prey. It greatly resembles the Hydra of Lerna with which Hercules fought during his heroic adventures.

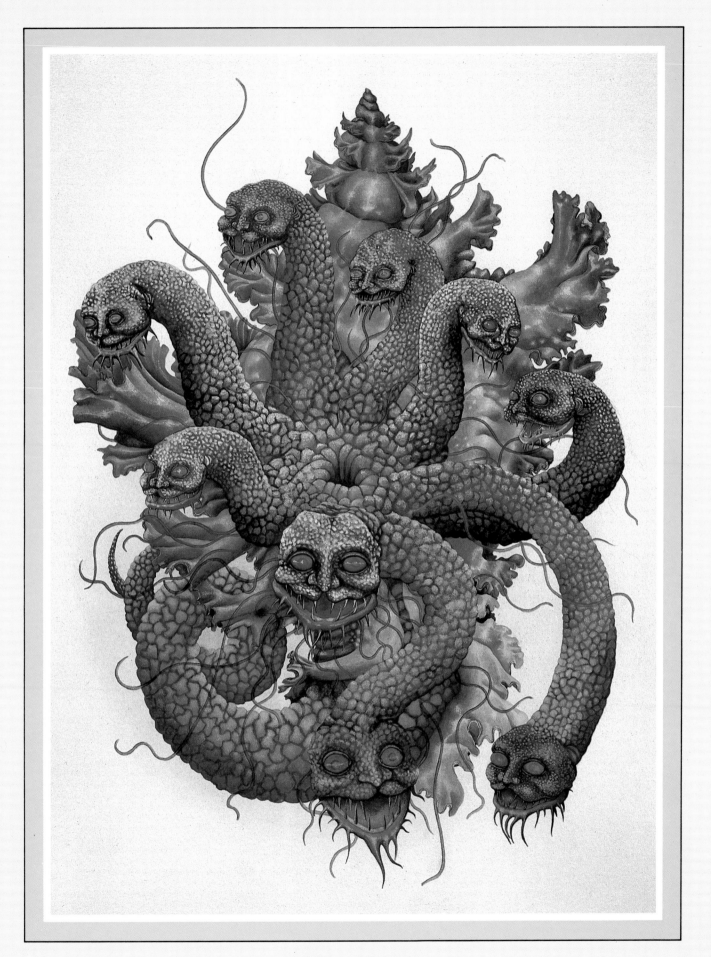

The Hydra

Pl. XLVII

DE LAPIDIBUS FIGURATIS

In Britanniae rupibus sunt multi lapides figurati qui praebent simulacra animalium marinorum. sunt autem aves, pisces, dracones, conchylia. quae formae apparent cum varietas caeli eas ciet e seminibus animalium marinorum vento importatis et in regionibus mediterraneis depositis. haec animalia lente crescunt, sed aliquando pari conspiciuntur.

Figured Stones

On the cliffs of Britannia are many figured stones which contain the representations of sea creatures. There are birds, fish, dragons, and shells. The forms appear when the conditions of the weather stimulate their development from the seeds of sea animals which have been carried by the wind and deposited inland. The creatures grow very slowly, but it is occasionally possible to observe them coming to life.

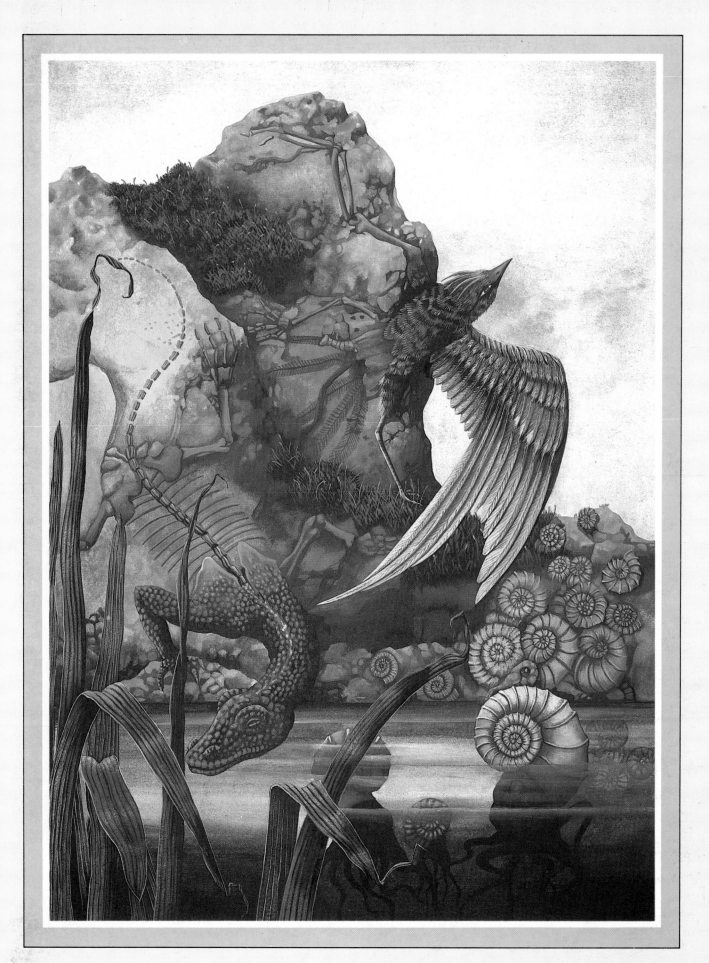

Figured Stones

Pl. XLVIII

DE DRACONE OCCIDENTALI

In regionibus mediterraneis, prope Aquas Sulis,
certiores facti sumus draconem quendam templum
Druidorum, rectorum Britanniae potentium,
incolere coepisse.

draco est anguis ingens, unguibus alisque
praeditus. spiritus eius tam calidus est ut ignem
iniciat.

multae draconis partes utiles sunt remediis
parandis; exemplum est unguentum oculis draconis
et melle compositum quod insomnia arcet. pingue
et cor, pelle cervino involuta adligataque ad
lacertum, dant victoriam in iudiciis. magi adseverant
neminem, usum draconis capite caudaque, crinibus
de fronte leonis et eius medulla, spuma celetis
victoris, ungula denique canis, omnibus mixtis et
pelle cervino inclusis, ullo modo superari posse.

quae seu vera seu falsa sunt, Druidi draconem
maxime timent et venerantur.

The Western Dragon

Inland, near Aquae Sulis, we heard of a dragon which had come to inhabit the temple
of the Druids, the powerful magi, the rulers of Britain.

The dragon is a great serpent with claws and wings. Its breath is so hot as to cause fire.

Many parts of the dragon are useful in the preparation of remedies; for instance, an
ointment of dragon's eyes and honey guards against nightmares, the fat and the heart
tied in the skin of a deer and attached to the upper arm makes for victory in lawsuits.
The magi assert that a mixture composed of the head and tail of a dragon, hair from the
forehead of a lion, and a lion's marrow, foam of a victorious race horse and the claw of
a dog all attached in a deer hide, will make a man invincible.

Whether or not any of this be true, the Druids have great fear and respect for the
dragon.

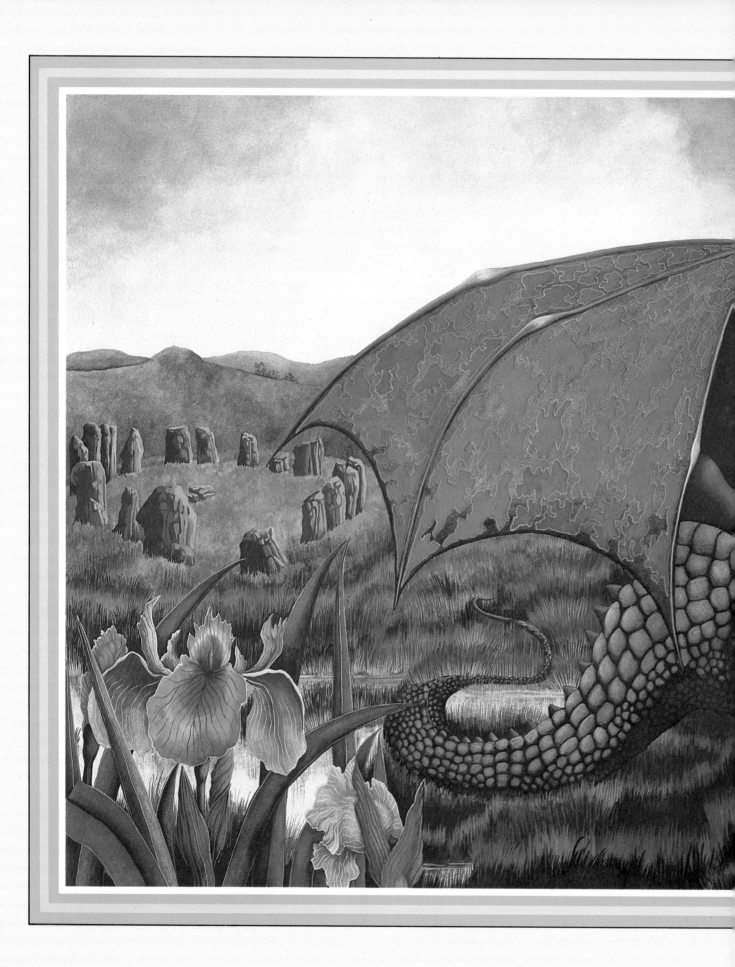

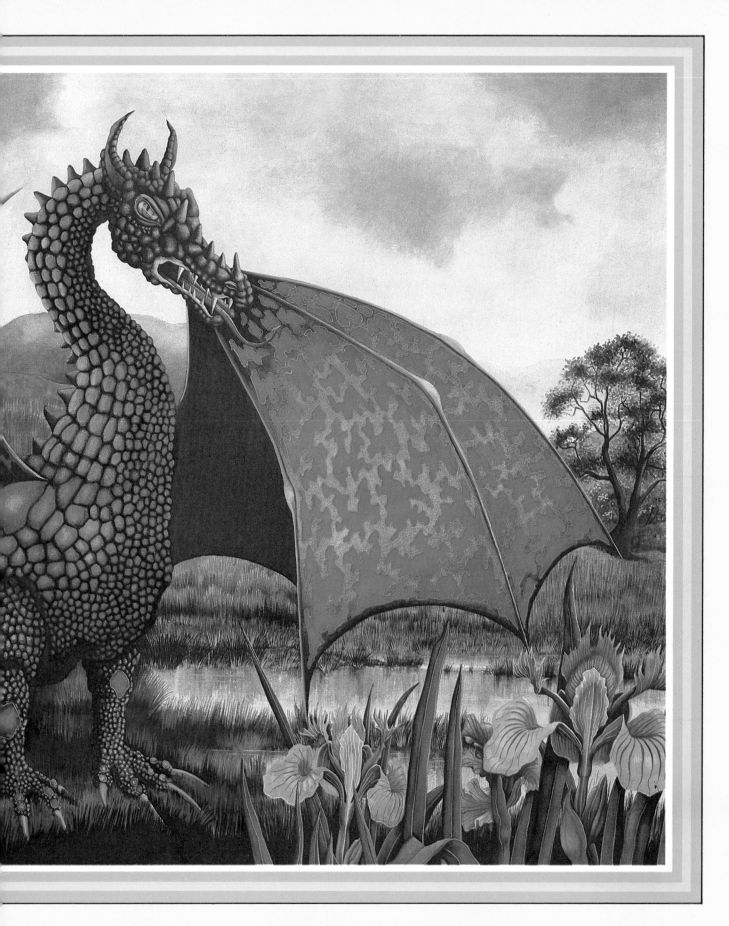

The Western Dragon

Pl. XLIX

DE SERPENTIS OVO

Certis lunae temporibus serpentes ita congregari
solent ut acervus contortus fiat. de saliva et spuma, e
corporibus convolutis eorum orta, res quaedam
effecta est, quae in globum rotundum et varium
indurescit.

·[. . . .] *hic serpentis ovum vel venti ovum
appellatus est. res huius generis Romae visae sunt.
Druidi serpentis ova maximi aestimant quippe quae
victoriam oratoribus comparare possint. ovum
verum esse ideo probatur quod etiam in auro
collocatum semper adverso flumine natat.

Snake's Eggs

At certain times of the moon serpents will gather
together to form a writhing mass. From their
saliva and the foam from their intertwined bodies
an object is formed, which hardens into a round
ball of varying appearance.

*This is called a Snake's Egg or Wind Egg.
Objects of this sort have been seen in Rome.

The Druids value Snake's Eggs as givers of
victory in the law courts. The test of a true egg
is that it always floats against the current even if
it is set in gold.

*Note: A considerable passage is almost obliterated at
this point. The words 'military cloak', and 'separated by
water', are all that can be deciphered. However, Pliny gives
a detailed account of the 'Snake's egg' in his 'Natural
History' (Book XXIX, chapter XII, lines 52-55), and it is
likely that these phrases refer to the ritual method
practiced by the Druids to obtain these objects.

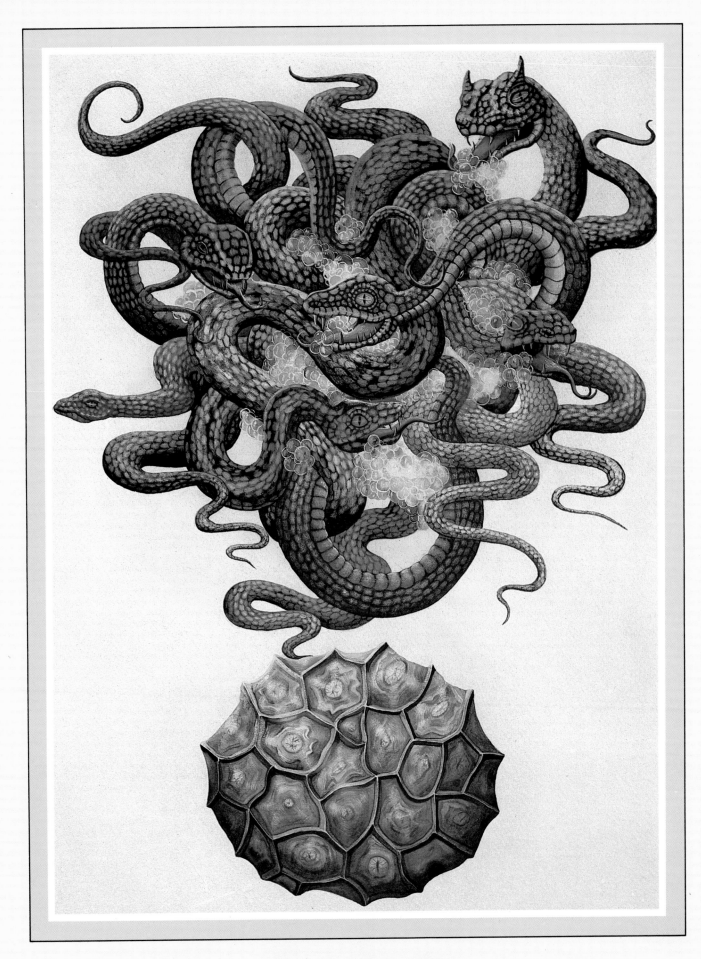

The Snake's Egg

Pl. L

*Note: Two short items are omitted here, due to their destruction, along with the original of Plate LI, in an attempt at Carbon-dating the manuscript (see Introduction). A catalogue of contents, prepared when first the work was made available to scholars, notes at this point a passage of five manuscript lines on the Druidic practice of astrology; and a somewhat longer one of twelve manuscript lines on the local British knowledge and use of medicinal herbs. Fortunately, Una Woodruff had made sufficiently detailed line and colour sketches from the original illustration, to allow the reconstruction that appears here (Plate LI).

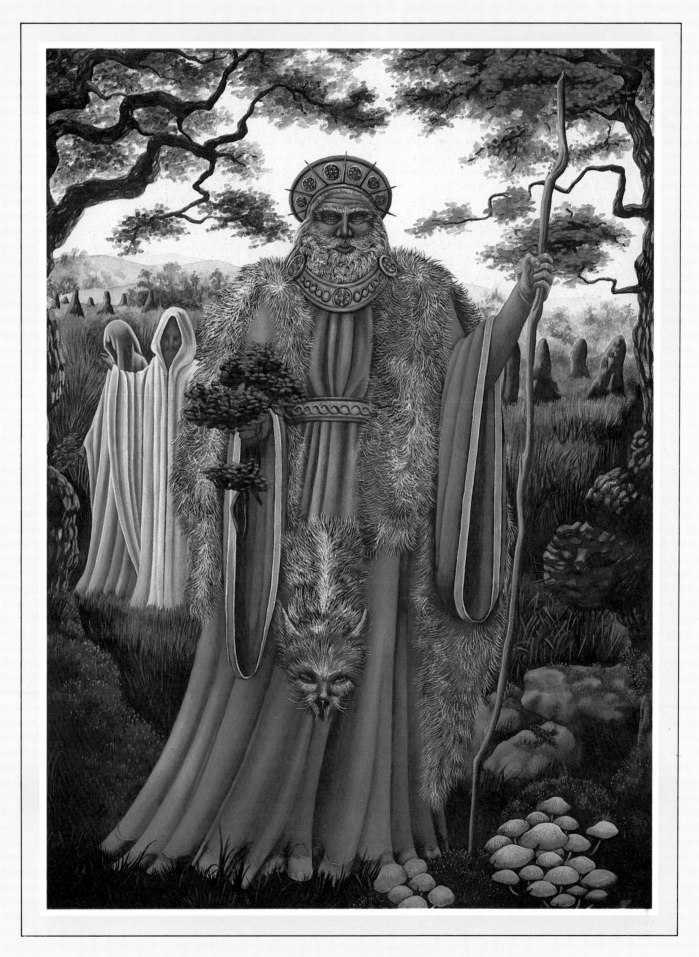

The Druids

Pl. LI

DE INSECTIS RORE GENITIS

Nos per paludes in parte meridionali Britanniae sitas procedimus quas vere frequentant insecta et muscae. haec gignunt et terra humida palustrisque et roris guttae in herbarum foliis stillatae.*

Insects Generated From Dew

We passed through the marshes of Southern Britain, which are infested, in the springtime, by insects and flies. These are generated by the damp boggy land, and from the dew drops gathered in the leaves of plants.*

***Note:** Pliny describes this process in detail in his 'Natural History' (Book XI, chapter XXXVII).

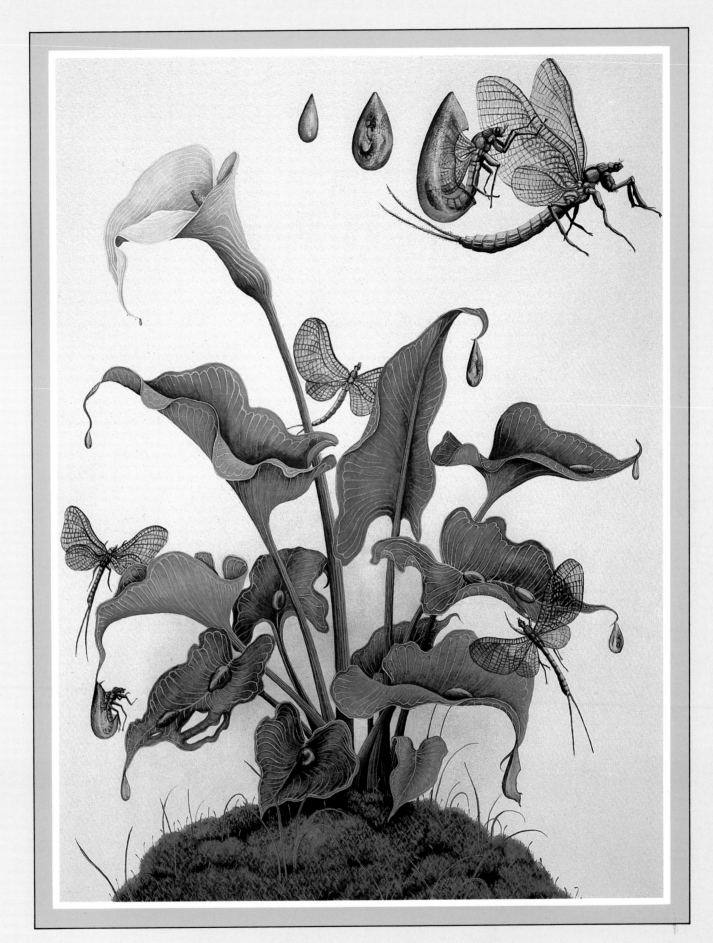

Insects Generated From Dew

Pl. LII

DE HOMINIBUS MARINIS

A Britanniae litoribus digressi oram Galliae et Hispaniae praeteriimus.

hae orae scopulosae notissimae sunt quippe quae sedes sint hominum multiformium qui mari orti sunt. Tritones, Nereidae et multi alii immanes sed hominibus similes in his locis saepe narrati sunt.

deinde postquam mare nostrum per Herculis Columnas intravimus ad patriam Italiam tandem revenimus.

Men Of The Sea

We left the shores of Britain and passed along the coast of France and Spain.

These rocky shores are well known as the dwelling places of many forms of sea men. Tritons, Nereids and other monstrous human-like creatures have often been reported hereabouts.

We entered the Mediterranean Sea through the Straits of Gibraltar, and at length, returned to our native Italy.

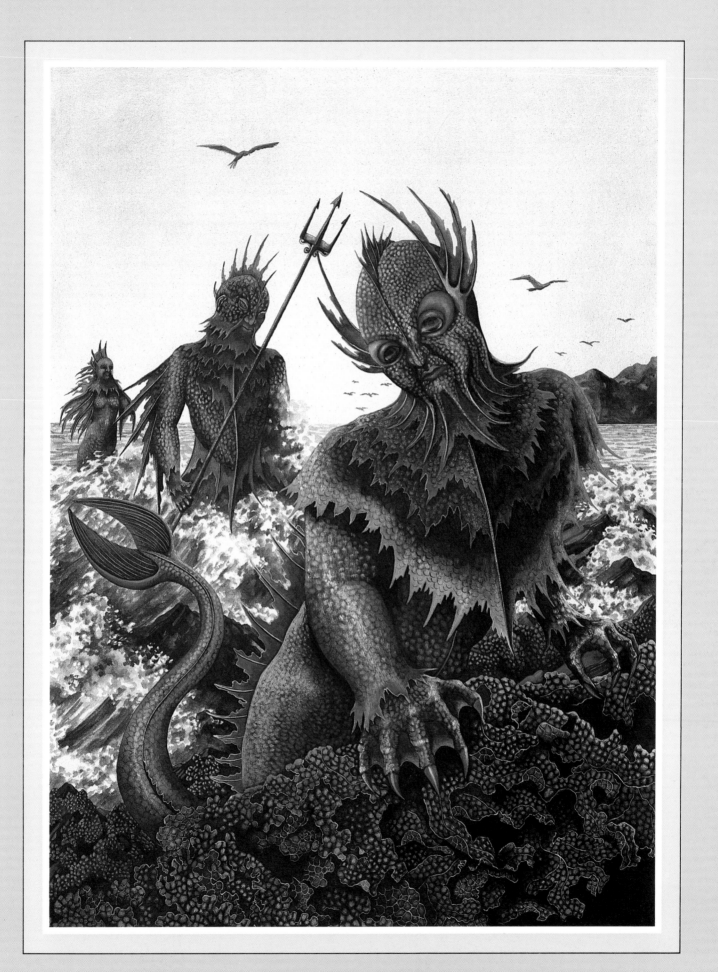

Men Of The Sea

Pl. LIII

EPILOGUS

Hoc iter quod circum totum orbem feci confectum est tribus annis tribusque mensibus. adnotavi autem permultas res de natura et incolis earum terrarum quas visitavimus. quarum rerum modo paucae in his paginis expositae sunt. equidem spero me hoc opus perfecturum esse atque collaturum omnia de rerum natura, de arte, de ratione physica, quae hominibus nota sunt.

GAIUS PLINIUS SECUNDUS

Salve, parens rerum omnium Natura, teque nobis Quiritium solis celebrari esse numeris omnibus tuis fave.

In Conclusion

The journey around the whole world was completed in three years and three months. I have recorded a great many facts relating to the nature and inhabitants of the lands we visited, of which but a few are presented in these pages. It is my hope to complete this work in the future and to compile a comprehensive record of all the facts of nature, art, and science known to mankind.

GAIUS PLINIUS SECUNDUS

Hail, Nature, mother of all creation, and mindful that I alone of the men of Rome have praised thee in thy manifestations, be gracious unto me.